Build a Better Photograph

Build a Better Photograph

A Disciplined Approach to Creativity

Michael E. Stern

rockynook

Michael E. Stern, michael@cyberstern.com

Editor: Jimi DeRouen
Copyeditor: Wes Palmer
Layout and Type: Terri Wright Design, www.terriwright.com
Cover Design: Terri Wright Design, www.terriwright.com
Printer: Friesens
Printed in Canada

ISBN 978-1-933952-18-5

Published by:
Rocky Nook, Inc.
26 West Mission Street Ste 3
Santa Barbara, CA 93101
www.rockynook.com

Library of Congress Cataloging-in-Publication Data

Stern, Michael E., 1956-
 Build a better photograph: a disciplined approach to creativity / Michael E. Stern. -- 1st ed.
 p. cm.
 Includes bibliographical references.
 ISBN 978-1-933952-18-5 (alk. paper)
 1. Composition (Photography) 2. Creation (Literary, artistic, etc.) I. Title.
 TR179.S74 2009
 771--dc22
 2008047317

Distributed by:
O'Reilly Media
1005 Gravenstein Highway North
Sebastopol, CA 95472

Adobe product screen shot(s) reprinted with permission from Adobe Systems Incorporated."

This book is printed on acid-free paper.

Table of Contents

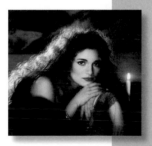
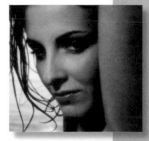

45 CHAPTER 2 Compositing Techniques

71 CHAPTER 3 3D Scanning of Found Objects

93 CHAPTER 4 Great Product Photography

Foreword

Just like David Attenborough coming across a seldom seen animal in the jungles of Borneo this book is 'a find', a very rare animal that has just been exposed to the eyes of the world. I have realized that after nearly 3 decades of working in professional photography and 18 years of teaching photography to aspiring professional photographers that there are essentially two sub-species of creative photographers in the world that can be easily recognized by the way each group deals with the essential skills and knowledge of the craft. There are the sharers and the keepers (those individuals who protect their knowledge as if it was a closely guarded secret). Michael E. Stern belongs to the sharers, a wise mentor who can't contain his excitement with the medium and would like to guide you through the journey of his creative process in order to help you on your own.

Just like a magician who has been given a large dose of truth serum, Michael spills the beans in this professional diary. His confession and advice serve to demystify and deconstruct the magic of his visual art. Michael rolls back his sleeves and shows us the process that produces the magic. Michael's honesty, wisdom, and teaching skills combine to give us a clear insight into how great photographs are pre-visualized in the mind's eye and then realized through the photographic craft. Michael walks us through the skills that were acquired during his days of shooting film and shows us those that are still relevant in today's digital workflow.

Michael has made the transition from expressing his creative ideas using large amounts of lighting to capture the idea in-camera to the new digital workflow of traveling light, using considered and economical digital capture techniques combined with appropriate post-production. Exposing the holistic process of creating digital fixed position montages gives us a rare insight into the cutting-edge contemporary craftsman at work. By reading this book you may feel reassured, as I do, that art is not the preserve for those that were born gifted, but a gift that can be passed down by good teachers. A good book can be a passport for these artistic activities to be nurtured and developed. This is one of those books, Michael's gift to you and me.

Mark Galer, BA (Hons), PGCE, M.Ed
Focal Press Author
Adobe Ambassador
Senior Lecturer at RMIT University, Melbourne

▶

My wife Meriel

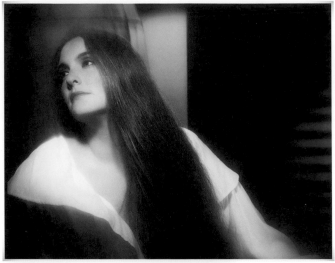

▶

My daughter Lauren

▼

My son Nathaniel

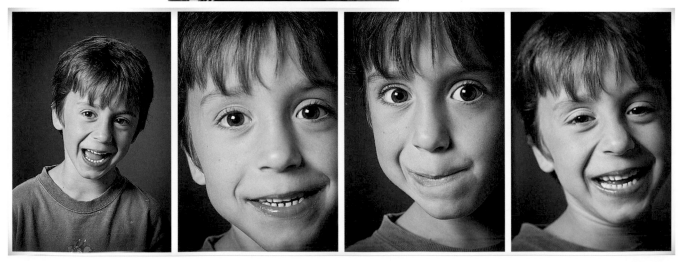

Acknowledgments

I want to thank all the people who appear in this book on my behalf. It was an effort getting the model releases but certainly worth the time and energy expended. I'm glad I could contribute to your 15 minutes of fame.

Thank you, Mark Galer, for writing the best forward this first time author could have hoped for. I am honored.

Jimi DeRouen at Rocky Nook has been in my corner since the beginning. He believed in my writing abilities before I did. Thanks, Jimi, for your guidance and support. And thank you, Gerhard Rossbach, for entering into an agreement with me to write this book in the first place.

Thank you, Pat Swovelin, for shooting the video footage on the DVD. Thank you, Razmik Mergadichian, for helping me put the DVD together. It looks great and is just what I desired. Links to their sites are on the DVD.

Thank you, Peter A. Duffy, Cole W. Eberle, and Matthew Gillis for graciously photographing me on set and for allowing me to use the pics.

Thank you Sid and Marty Krofft Pictures, Inc., Harris Corporation, and The Walt Disney Company for being "entertaining" clients and for helping me reach my career and life goals. I had a great time shooting and providing lab services.

Roy Disney, Gere Kavanaugh, René Zendejas, and Sam Maloof appear in the chapter about environmental portraiture. Without your permission this chapter wouldn't have been worth writing. Thank you all.

My family left me alone when I needed time and space to write and didn't say a word about all the hours I spent holed up in the office. Thanks to my wife Meriel, son Nathaniel, and daughter Lauren.

Finally, I especially wish to thank my brother Fred. Over the course of my career (with all its success and failures) he has unconditionally supported me and provided guidance. In my darkest days, he brought comfort to me in a way no one else could. Thanks bro, I love you.

See ya!

Diana, who as a child modeled for Snowy Bleach.

Introduction

This book is dedicated to elucidating the concept I call the "process continuum", in the hope that photography enthusiasts, entry-level, and mid-career photographers will benefit from its lessons and examples. This glimpse into the inner workings of a professional photographer who has developed methods for a creative process that works will hopefully bring some validation to your own thoughts and creative processes. I began my career as a photojournalist. Creating my own reality, however, was more fulfilling and challenging than documenting reality, so I moved into commercial work. I am a classically trained photographer. From 1979-2001 I worked with film and darkroom techniques. I was trained to create images for reproduction on printing presses, and out of all the film techniques I learned in school, grinding my own chemistry with a mortar and pestle was the most noteworthy.

Successful creative people work within their own process continuum that is actively managed through a flexible set of rules that guides their career as it moves through its inevitable successes, failures, setbacks, and conflicts. Like the propeller on a ship, this management process propels one's career forwards or backwards. Acting like a rudder, management of this continuum also keeps careers centered if they start to drift, or one can steer themselves onto an entirely new and different career path. I started working a month after graduating from Art Center College of Design in 1979. I opened my first studio in the heart of Hollywood late that year, shooting for Star-Kist Foods, and shooting actor and model headshots. Many months later, after an unpleasant parting from my studio partner (read more in the product chapter), I moved to Burbank. Hi-ho, it's off to the entertainment industry I go. From this location, I eventually worked my way onto the Walt Disney Company's radar (after two years of phone calls and portfolio presentations) where I enjoyed a superb working relationship for close to 20 years. The Mouse was very, very good to me. I also photographed architecture for 15 years.

Since 2003, I have mostly been teaching, writing, reviewing manuscripts, and running workshops. I occasionally appeared as "Mr. Pixel" on www.phototalkradio.com between September 2006 and December 2008.

What follows is mostly about the journey undertaken to discover my creative process. I've also written a bit about my business practices, photographic theory, Photoshop, and a few anecdotal stories. Included are examinations and appreciations of the relationships and strategies one develops as a result of being a self-employed commercial artist. Be mindful these are my strategies and how I've made them work. Take away what you can and tweak them to fit your goals.

While you read through my thoughts, ideas, and stories, and review my photographic examples, diagrams, and screen shots, you may wonder why I included the two stories briefly describing the conflicts I endured, one from my best shooting account and the other from first studio partner. I take you through my experiences to illustrate how conflicts can rise

up at any moment, or slowly build over time; that you have to be aware of the potential for conflict so that if and when a conflict occurs you can effectively deal with it by employing carefully thought out strategies. That's how I look at it now, but when I was in the middle of the first conflict, I felt differently and dealt with it differently. Filtered through the lens of time and maturity, I am reliving these two events to put them into context so you can benefit from how I worked through them. I was successful with both, but approached them from two different perspectives. The studio conflict was first and the Disney conflict happened 17 years later. Given the length of my career, to have only two real conflicts is quite remarkable. I attribute much of this good fortune to my passion for being successful. Everything I do is done to allow me to spend time with my family and friends.

Conflicts too are a part of the creative continuum and they too have to be managed to help secure that next job, idea, or referral. It has been my experience that these two important aspects of being self-employed (creativity and conflict) are inseparable, the yin and yang of valuing your self and your services in the marketplace of ideas and commerce while being compared to your competition in the very same marketplace by the very same clients you hope will select you instead. Conflicts are stressful and they need to be managed properly or anger will result, impeding progress towards stated goals.

I've not been perfect in managing both the highs and lows of my career. Obviously I share some responsibility for both, but I learned from them and put these two conflicts behind me. I have managed them well enough to enjoy my lifestyle, where I live, and my relationships with my immediate family. Money is

important, but it ain't the only thing. I work to live, not live to work.

A similar challenge occurs when you are an employee. You'll have good boss (client) days and bad boss (client) days. Don't get too high with the pats on the back and don't get too low with the inevitable talk in the office about a project or task that wasn't done satisfactorily.

When managing a success, don't take it for granted. Manage it by thanking your client for their confidence in your abilities and opportunity to provide your service. Be aware, though, that it can go south in a heartbeat. A misplaced casual comment, misinterpreted eye contact, or a poorly-timed joke can all begin the process of self-doubt or worse: your client doubting you and your abilities.

Another metaphor I often use when speaking with students: I am wearing a suit of armor and it is shiny, well-oiled, and very flexible. Every interaction I have with a vendor or client either buffs this shiny suit to a higher degree of shine or dings it a bit. If I don't take care of the real or imagined slights to either my client or vendor, then the dings can build up and turn into rust. Soon, I will not only be inflexible, but immobile and unable to accomplish what I need to do in order to be successful. This metaphor actually can be applied to many aspects of one's life.

This book is organized into four chapters: The Environmental Portrait; Compositing Techniques; 3D Scanning of Found Objects; and Product Photography. In these four chapters the creative process and the technical methods used to create the images are discussed in a variety of ways. Additional information is included on the companion DVD.

I have been teaching photography at a variety of educational institutions since 1987,

and I love teaching as much as I love shooting. Among the places I have taught are Los Angeles Trade Technical College, Art Center College of Design, Glendale Community College, Burbank Unified School District, Julia Dean Photographic Workshops, Studio Arts, Fashion Institute of Design and Merchandising, and Brooks Institute. Early on I taught film and darkroom techniques. When I began teaching digital photographic techniques, I had to solve the dilemma of how to teach an appreciation of the rich history of film techniques, theory, and practices as a foundation for building students' knowledge without using a wet lab or film.

My book is designed to help you on your quest to expand your photographic knowledge and creative selves.

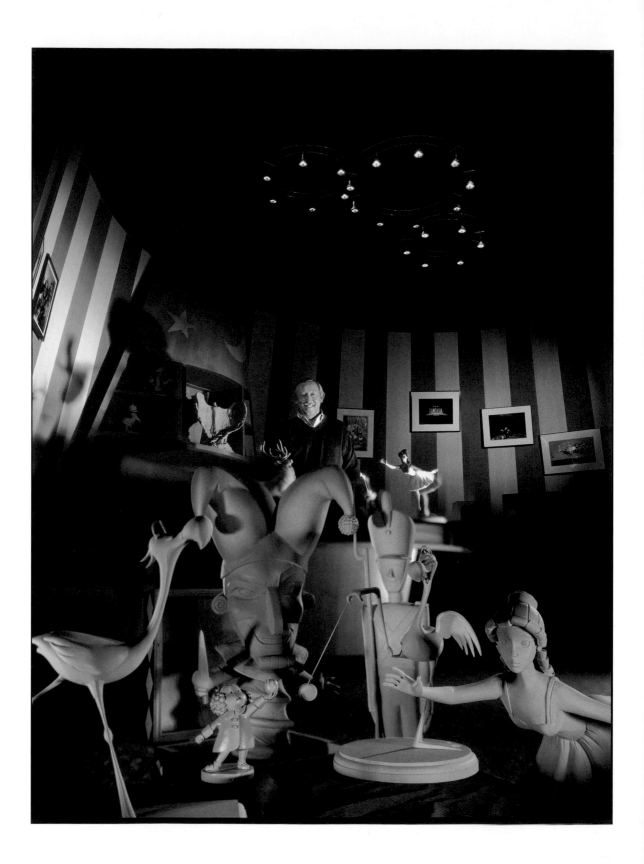

CHAPTER 1
The Environmental Portrait

In this chapter I discuss my creative process and approach to environmental portraiture, and more specifically my use of digital technology in the process. I'm an artist, and my creative process begins by using pre-visualization techniques. These techniques are the starting point for everything I do as a creative professional. In my mind's eye, I work at seeing the end result first. This pre-visualization can be triggered by client requests, someone I've met, something I've eaten, something I've seen or experienced, or just by working out an idea that has struck me.

The Image Hit

My pre-visualization techniques take a serpentine path. The creative process pulses, breathes, and moves through an artist's system. It flows with passion, anger, joy, love, desire, and fear, among other emotional stimuli. Add your own emotion to this list. An "image hit" informs the emotional responses I feel after experiencing one of these stimuli. I feel my response to the person, to the action, to the food. This is how it begins.

I pull my camera angles, lighting scheme, color relationships, subject key (brightness value) color, contrast ratios, props, costumes, location, studio—everything—from this image hit. During this process, I construct a complete world in my head about the subject. This world may contain all or part of the following: time period, family, friends, indoors, outdoors, clothing, activity, attractiveness, age, intelligence, pose, status, wealth, and so on. Image hitting works for me all the time; in fact, the more I'm in touch with my emotional responses to the world and people in it, the more powerful and clear my images become. But it takes work, commitment, and flexibility—in large quantities. Critical thinking and critical choices are made during this time. It's tough and frustrating, and I frequently don't see the end point for quite some time, but the rewards are worth it.

With this image hit, I create a story in my mind. This story has a beginning, middle, and end. I then communicate this story—in part or in whole—to the subject. The goal of the session is to capture a specific moment of the particular story I'm trying to tell. In effect, I capture a slice of the story: the decisive moment where all of the elements I've assembled gel into a cohesive whole.

During the photo session, my job is to cajole the subject into a state of mind and pose that goes beyond where I eventually want him or her to be. Then, like letting air out of an overfilled balloon, I slowly and carefully bring him or her back to the perfect emotional spot. This art form takes lots of practice to finesse.

◀

Roy E. Disney posed for me in this office, modeled after the sorcerer's hat in the original *Fantasia*.

I've been successful with even the fussiest of subjects. I apply a modified version of this technique to my professional/commercial portrait subjects, too. There isn't as much prepping when I shoot a commercial headshot, but the cajoling is no less important. I have to deliver the expected result. Period.

The goal of my environmental portrait work is to suggest to the viewer that there was a moment in this person's life that came immediately prior to the moment they are seeing, and a moment that is going to occur immediately afterward. I'm building and photographing the moment in between.

Working Out the Idea

After the image hit, the concept and story get fleshed out. The concept is frequently inspired by a client request; at other times by meeting someone, seeing something, or experiencing an event. Sometimes a shared moment with a group of people begins the process. I am compelled to begin because I need to create. I need to create to live and flourish. Creative people are, by definition, compelled to follow this creative, emotional path, for it is a powerful way in which we define ourselves as people and as artists.

After thinking and dreaming about the idea, it's time for sketches, notes, and research. Included in this process is talking to the prospective subject and getting him or her to buy into the idea. If need be, I try to get the subject to take some ownership of the idea by contributing in any way that gets him or her to buy in. When subjects get to this point, I have them. They tend to work with me more if they have contributed. I feed off collaboration. I like working with a group. Ultimately, though, it is my idea and I make the final creative call. But

the process of including others is invigorating and, for me, necessary.

I ask myself what I would like to see and experience emotionally. If it is a commercial project, does it fit the requirements? I then look to my favorite source of inspiration: movies. Movies inspire me: they are visual, they tell stories, and they have color. They have an emotional core that resonates with me in powerfully compelling ways. I am mesmerized and entertained by the power of film storytelling.

Going to museums and cultural events is another source of inspiration for me. Oftentimes I'll meet someone new who inspires me and moves me closer to my goal of being a successful, long-term, self-sustaining artist. Overhearing a conversation, reading, talking on the phone—all of these experiences have the potential to trigger visual stories. Being aware of one's surroundings and influences is a crucial and important step in the creative process.

It takes a lot of discipline and daydreaming to pre-visualize creative solutions, and I attempt not to filter out any potential image-hit triggers. There is danger, though, in not filtering out input triggers. I often become emotionally upset. I go for as much input as possible, but this frequently leads to distress. I try not to block things out but rather to let life hit me head on. I often pay the price, as do the ones closest to me, when I get upset. This is the way of the artist. We can seem unstable at times. I don't deny getting thrown off my game on a frequent basis. I try to work with it in a constructive way, but for me, this is very hard to do. I find out a lot about myself during these episodes and view them as a form of therapy. This process opens up visual solutions. I end up contemplating my place in the world. How could it get any better?

Preproduction

The preproduction step requires meeting with the specialists whom I engage to help me work out exactly how the image will be produced. The team helps me work out the quality, direction, and color of the lighting setup, refine the story idea, lens choice, imaging format, hair, makeup, styling, props, food, drink, budget, and postproduction. This part of the process gives all involved a clear idea of what I'm trying to accomplish. I want to make all aspects of the project clear, so I spend time on this step. There are no shortcuts.

The Multiple-Exposure Environmental Portrait Concept

Why am I interested in creating environmental portraits of people whose careers have impacted our culture? I want to honor these people who have compelled me to think differently after watching and consuming their work.

For example, The Walt Disney Company was a house account at my various studio locations from 1982 to 2001. I learned a lot from my Disney clients during this time. Providing excellent service with a genuine smile, delivering near-perfect technical solutions to the variety of products and services offered, and never missing a deadline carried me far, and in turn they gave me tremendous creative freedom. For almost 20 years I maintained a healthy working relationship with over 80 buyers at Disney. This relationship is my legacy and I am grateful for the time spent with these clients. Roy Disney commissioned me to create this portrait of him in 1998. (More about this later in the chapter.) This was the zenith of my relationship with Disney.

I took for granted my clients would always think of me first. After all, we had an established relationship. I learned the hard way (my usual early career path) that taking things for granted leads to disappointment. I came to understand I had to be vigilant and pay attention when they spoke. At the same time I was always working myself into a position where they thought of me. Art is my profession. Selling is my job. During a dinner with clients from Welcome Enterprises (a book packager), hosted by my wife and me at our home in Burbank, the question came up: "Who was going to shoot Roy's portrait for the upcoming book?" Who? Whooooo? Me! Yoohoo! Over here! I "asked" to be considered. I was right under their collective noses. I was practically jumping out of my skin.

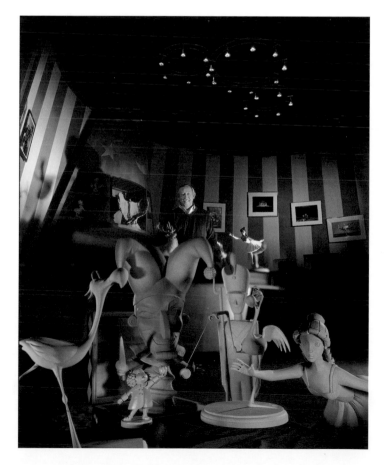

How could they not have thought of me? The future Mr. Pixel, I dare say. Because I made noise, I got on their radar for this job. It was a perfect fit. Squeaky wheel gets the grease. I volunteered to do some concepts, pitch it to Roy, and see if he saluted. They agreed, and I was thrilled. The lesson here is to never assume a client has you in mind. They are busy people with many responsibilities and distractions. In this case I had been working with Welcome Enterprises for six years, but in a very specific capacity and it did not occur to them that I might be the right person for the job. It was up to me to show them the other areas of my expertise.

Six weeks of preparation included location scouting, test shots to develop concepts, making collages for review and approval of final concept, meetings, phone calls, e-mails, faxes, hiring makeup and other assistants, film stock tests, set dressing, and a full day of lighting.

This was the last large-scale, big-budget, film-based environmental portrait I shot. No Photoshop—all done at the moment of exposure. Eleven lights were used, all of them colorized with heat-resistant lighting gels. I ordered a split-field filter for my medium-format, rear-floating-element portrait lens. This specialized filter allowed me to hold crisp focus on both the maquettes in the foreground, and Roy in the background. The nearest maquette was one foot away; Roy was 18 feet away. Shot at f/11, there isn't a lens in the world capable of providing enough depth of field (even if stopped down all the way) without some unique help. A split-field filter is best used on a plain, single-color background. Look closely at the ballerina on the desk: you can see the telltale sign (partial double edge) of using a split-field filter. I was mindful of where I positioned the ballerina, to minimize the effect of using a device against

its intended purpose. Rather than eliminate this partial double edge, I incorporated it into the scene. My motto: Make it work.

The portrait appeared in the book *Fantasia 2000, Visions of Hope*. Roy wanted a creative photograph of himself to run on the same page as the foreword he wrote for the book. Especially sweet is my photo credit and copyright symbol alongside the photo. During my career, I worked on 55 book projects for Disney. Welcome Enterprises, Inc., produced book projects for Disney's publishing arm, Hyperion. I worked for both entities, photographing two- and three-dimensional artworks for books, editorial pieces, and auction catalogs.

The Cool Trifecta

As promised, here are the particulars of how I worked out my concept and budget for this portrait. My research revealed that Roy liked to be photographed inside the ceremonial "Sorcerer's Hat" office in the Feature Animation Building (FAB). The location was set. Cool. Now I just had to figure out how to create something unique for him. Roy very politely and clearly explained that everything in the shot (props, maquettes, photos, and paintings) had to refer to Fantasia 2000. He was also clear about being tired of almost every photo of him being a head-and-shoulders pose and he wanted this portrait to be different. He didn't like some of his facial features, and wanted to minimize these attributes. It's great when a client gives strong and specific input, and it's something I can work with. Cool again. I went to the Hat office to shoot point-of-views (POVs) at various camera angles, focal lengths, and orientations to see what worked best for the story, subject, location, and me.

▲

This office was built in the shape of the sorcerer's hat that Mickey Mouse wore in the original Fantasia; hence the name. This is what I started with.

I made several mock-ups showing the POV that I wanted to use. I copied several maquette photos from a previous auction catalog I shot of Disney animation art and positioned them to indicate where I planned to place the Fantasia 2000 maquettes in the composition. I made an appointment to see Roy and pitch the idea. I'm in his office on the studio lot, and man is it sweet: spacious with dark wood, white carpeting, and white furniture. I'm very excited about being in this position! I want to make an impression, so I take off my shoes and, in my best passionate-artist routine, jump onto a white chair as I make my pitch: "This photo is of a man surrounded by the successes of his career. He has momentarily stepped into his study to refresh himself before venturing out again to a gathering of friends and associates

in the other room. As he stands behind his desk (no head and shoulders here) he wears a contented smile and is bathed in the warm glow of an off-stage fireplace."

Picture me saying this as I'm jumping onto the furniture, making the classic director's gesture, framing Roy with two hands, and wildly describing my vision. I jump on a chair. I jump off a chair. I move toward Roy. I move away from Roy. All the time framing him between my hands.

His response: "I like it! Let's do it!" He makes some calls. I now have to get cracking on a budget proposal and get it approved. Cool for a third time. The cool trifecta.

Roy's only request was to leave a family photo in the final image, just for fun. No worries. I always accommodate my clients. The photo is on the wall on the far left side.

Creativity, Money, and Egos

I've included this section to help other self-employed artists stay the course. As great and as much fun as it is to be called upon to do what you love, it's not without its anxiety producing moments. Creativity, money, and egos can be a treacherous mix. To wit: for years I had wanted to write a book about my career. With this end in mind, I knew I had to negotiate an agreement where I would own the images from the shoot; I would then license reproduction rights to The Walt Disney Company for the book.

I developed a budget and sent it to the executive in charge at the publisher with whom I'd had a good working relationship with for years. She sent the budget to Roy. We exchanged phone calls. We agreed that Hyperion would license reproduction rights for use in this specific book only. There would be no limitations on how many times the book could be reprinted, in what language, or in

what country the book was sold. Reproduction rights would be attached (permanently) to the book; all other reproduction/licensing rights would remain with me, including the copyright and physical ownership of the film. It is important for professional photographers to think about the future use of their images, without which I would not have been able to use this portrait for the book. Let's hear it for the little guy. You must negotiate for what you want because clients will rarely think about what is best for you. It's not their job, it's yours.

The budget was then sent to the publicity person on the Disney lot whose signature was needed on my copy of the budget document. Her tone, as they say, was decidedly different. I called to meet with her and to plan a production schedule. She let me know straight away that she was not happy with this budget. Who was I again? Who commissioned me? Why wasn't she informed ahead of time? Why was I the one to contact her? I could only answer the questions for her that I could. The shoot was budgeted at $8,000.00. She told me her usual budget for a full day of set shooting was $600.00 and she got all the film and copyrights. Had Roy seen this budget? I said yes. Had Hyperion seen this budget? Yes again. She was frustrated, but given that Roy, Hyperion, and I were already working with these numbers, she agreed. She was trying to do her job and I was sorry she had not been informed prior to my phone call, but what else was I to say to her: I was an outside provider, not a company insider. This proved to be troublesome.

We agreed to schedule the portrait ten days hence. At that point, I let the publicity person know that I would be putting a hold on equipment rentals, a makeup artist, and an assistant, and that I would need the signed budget 48 hours prior to the shoot or I'd release the hold as I didn't want to be held liable for the costs. I really wanted to do this project, but I did not want to be taken advantage of. I'm on equal footing with my clients; I have something of value to offer my clients and they have something of value to offer me. We work together. It's a creative and collaborative process. It helps all involved to grow and advance a bit further down the line. I have let a number of projects go over the years because a client would verbally agree to a budget, but then would have issues about actually signing the document to make it official (and, if need be, enforceable). Sometimes, clients who receive regular paychecks act towards self-employed people in ways that create unnecessary stress and anxious moments. I put my reputation on the line every day. How I act affects the number and quality of opportunities that are available to me at any given time. These opportunities come from all over and at unpredictable times. My family depends on this. I depend on this. I believe the philosophy that we must all try to work and play well with others.

On the morning of the eighth day (when I had to either confirm or release the holds) I called and informed the publicity person that the day had arrived to sign off on the budget proposal, and asked her to either fax it to me or messenger it over to my studio. After several failed attempts at faxing over the budget with a legible signature (the signature was not legible until the document was turned around), and after several phone calls placed from my end, I finally received a legible copy. At five PM on the nose! On to the shoot.

The Session

The day before the shoot, my assistant and I had set the lighting and shot test film to check the speed, color, and lighting contrasts. When the big day arrived, we were ready to go. The set was dressed as Roy had requested. My hair and makeup person was ready. Wardrobe was ready. In comes Roy. I show him the test footage (I wanted him confident about what was "going in the can"). The first setup is shot (the lead-in photo of the chapter). As part of the deal, I also shoot a setup of Roy sitting at the desk in a medium shot and we also made some standard head-and-shoulder poses for other possible publicity uses. As we prepared the second setup, in walked the publicity person. The camera was set, the lighting was set, and I was precisely moving the props on the desk and shelves behind Roy. She walked over and started moving things around. I was stunned. She didn't even ask; she just assumed she could walk in and do as she pleased. I was shocked by this behavior and felt this was disrepectful but, exercising restraint, I asked her why she moved some of the objects. She said because it didn't look good from where she was standing. I agreed with her and said "Because you weren't looking at it from the camera position, of course it wouldn't look good." From camera it looked great, so I move the items back in place. Precisely back in place. She said, "Oh don't worry. With our other photographers, when they don't get it right we retouch it later." Aha! I have my opening! I seize the opportunity and say, "Well that's the difference when working with me. I hand you a perfect piece of film and you're ready to go to press." This appeared to upset her, she stared at me and walked out. Fortunately, Roy was in makeup and missed the entire exchange.

The remainder of the shoot went fine. A few days later I showed Roy my selections from the shoot. He picked two that he liked: one for the book and one (at his desk) for PR purposes. We were in agreement that none of the head and-shoulder poses worked. As a courtesy, I also sent a set of proofs to the Publicity Stills department. I walked into that department after meeting with Roy and met the publicity person, working with an assistant, going over the head-and-shoulder poses and discussing how they were going to need to have the film retouching." It was taken aback. I took a moment to collect my thoughts and then said to both of them, "Roy picked the ones he would like to use and he doesn't want to use any of the head-and-shoulder poses. He feels they're unflattering." She said, "What do you mean Roy picked already? He's seen these already?" I answered, "Why yes, he has. He commissioned the portrait and wanted to see them ASAP. And look, they don't need any retouching." It was obvious my presence was creating tension, so I left. I felt bad for her, and yet I had done my part and delivered a completed assignment to my client's satisfaction. Several weeks later I gave Roy a framed enlargement of the portrait as a thank you, and he told me then that my portrait was his favorite. It was very gratifying to hear his kind words.

Epilogue

The book was published. Everyone (well, almost everyone, I suspect) was happy. After the book was published I got a call from the same publicity contact. A decision was made at the studio to begin negotiations to purchase all rights from the shoot, including the copyright transfer. Now this is the most expensive way to purchase commercial art. In a copyright

transfer, physical ownership of the film is transferred to the buyer and the buyer can then lay claim to creating the image. The new copyright owner can resell the image to a third party. They can edit and transform the work in any way they please. The creator/artist won't be able to show the photo (in public, in a portfolio, on the Web) without the owner's written permission. The artist would not be able to say publicly that he or she created the work. Therefore, there is a high cost associated with this type of purchase.

I offered to sell copyright to all the images for $250,000. The publicity person said, "Well, we never pay more than $5,000 for a copyright transfer." She named a well-known photographer who she said had transferred his copyright from a shoot to Disney for $5,000. I knew the photographer and doubted the veracity of her assertion. However, we talked a bit and finally I agreed to sell 23 frames from the head-and-shoulder poses and some of the images from behind the desk but not the poses from the main setup. She agreed and we worked out an agreement stating I would receive photo credit on any and all reproductions and permutations of the transferred images. I love to negotiate. The check arrived very soon and I cashed it. The contract arrived after the fact and it contained a whole lot more than we had discussed and agreed to. I wrote a detailed letter and sent it with a copy of their contract with the provisions I didn't agree to crossed out. I said I wouldn't sign it until the contract reflected what we had previously negotiated. As a show of good faith, I included the 23 images with my letter. No copyright transfer occurs, however, without a signature, regardless of whether or not money changes hands. I had my fee of $5,000 and they had the images we agreed would be

purchased, but not the copyright. You have to be strong-willed to be self-employed. If you aren't strong, you might not get paid. It's tough. It's fun. It's rewarding. I have yet to hear back from them.

Always try to behave professionally (in every sense of the word) and over the course of your career you'll come out ahead more often than not.

The Beginning

The following is my story of the ground-zero portrait that was my entrée into digital multiple-image compositing as it relates to environmental portraiture.

I like telling the story about this photograph, which was the first multi-exposure environmental portrait I produced using digital capture. Multi-image photo-compositing techniques have been around since negatives were made of stone. The problem was that the process is time-consuming and tedious. Some compositing techniques required hole-punching unexposed film to allow pin-registration of the various processed exposures afterwards for exact alignment while printing. If a composite required different film stocks, a problem sometimes occurred. Film stocks expand and contract during processing. Due to the different rates of expansion and contraction, the film could become misaligned after the fact. This, in turn, created out-of-register composite images. As if that weren't enough to cause a redo, if you made a mistake during the assembly of a composite at, say, step 13 out 16, you often had to go back to the beginning and start over. If you didn't start over, the mistake could easily get compounded, as the compositing of additional film layers over flawed film layers would lead to a compromised composite.

Not so with digital. You say you made a mistake on layer 27? No worries. Just replace or re-edit that layer and keep on moving. Working digitally means you can work on it until it's right.

The portrait of Gere Kavanaugh represents the first time I successfully employed digital capture as the method for my type of multiple-exposure environmental portraiture. What a relief to have a new solution to an old problem. I was indeed a happy man.

In 2002, Gere was receiving a design award from the city of Los Angeles. Gere asked me to create a publicity photograph of her for the awards catalog. I asked Gere if I could experiment using a digital multiple-exposure technique that began rolling around in my head back in 2000. What I learned from this session was that, with very little lighting gear (one diffused light and one specular light with a grid spot), multiple exposures, and a locked-down camera position, I could produce complex images to tell my stories.

I know this isn't news for some; as previously stated, the effect can be achieved by using film techniques. In fact, this technique has been around for decades. But digital photography makes it much easier to create these wonderfully illustrative and conceptual images. And if you make a mistake or want to edit a portion (or portions) in the future, you don't have to go back to the beginning and start over. Nowadays, all you have to do is pick the Photoshop layer or layers and let 'er rip.

Gere Kavanaugh

So you've read my ramblings about the image hit. Now, I want to walk you through my process of creating this portrait of Gere.

The initial concept was to illustrate the many different things she represents to me. Gere is a designer of objects and spaces; her home is a monument to her art and that is what I wanted to portray. Her thoughtfulness also had to be captured. These elements were to be brought together into a multi-image environmental portrait.

One light shot through (as opposed to bouncing out of) a 36-inch silk umbrella creates the light quality I look for in representing skin tones. A direct light shot through a medium-coarse grid spot was set up and pointed at the hanging sculpture located rear stage right. Notice the cast shadow on the wall. I calculated an ambient light exposure value so the room lights would have a material impact on the color and mood of the portrait. For every environmental portrait I create, I blend the ambient light with the light(s) I bring to the scene. This drives my decisions on how mood will be drawn by the lighting.

The result of the idea in my mind's eye is shown at the far left on the next page. I had achieved what I wanted—that is, what I had seen in my mind's eye—but it just didn't work. The creative process demands flexibility. Know when something isn't working and try again. The one good thing about getting older is knowing what works for you and what doesn't. It is, in fact, the only thing about getting older that's good.

I had the photos in hand, they just had to be reconfigured.

The middle image was shot first. Once the camera position and lens focal length were selected, they were left unaltered. If I had kicked the tripod after making any of the exposures, it was back to the beginning. You can make it work if the camera moves (it's digital, after all), but lining up the elements can be time-consuming. Once the aperture is locked down, so is depth of field. To alter the ambient

▲ The end result of the first attempt.

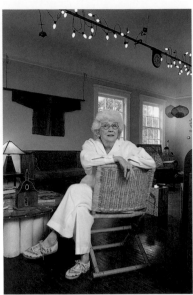

▲ The first exposure.

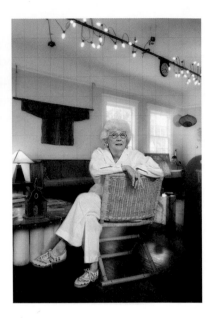

▲ The end result of the second attempt.

light levels the shutter speed (time) is adjusted, as can be seen in the noticeably darker far right image on the next page. By moving this camera control instead of the aperture, depth of field (selective focus) is preserved. This is an important step to remember. It helps create the illusion of a single-exposure photograph. Once I had made the final decision to go with just the single image of Gere—instead of trying to rework my original concept—I finished off the story by adding a grid over the top of the image. This story speaks to the precision necessary when designing spaces and objects. Gere is a precise person with unusual taste in shoes.

Since I had planned to create this shot using separate, individual exposures, I was not concerned about blending mismatched densities. A fixed camera position, fixed focal length, and fixed f-stop contributed to making this project go. At this point, it becomes a matter of vision, taste, and desire to see it through without compromise.

Look again at the image above on the far right. For me it was not completely satisfying, but it provided a great foundation and tremendous learning experience. With this simple setup of two lights, two stands, one tripod, it became clear: this was the photographic process for me.

The Layers Palette for Gere's Portrait

I've divided this pallette into sections for the sake of clarity. I think you'll find the following information helpful especially when comparing it to my current layer workflow examined later in this chapter.

The Layers Palette for this image is confusing and I'm embarrassed by how it's structured. Why two **Jacket Groups**? Some of the layers don't have meaningful names. Layer 2 contains what information exactly? With only a few layers in a file like this it's still an issue to have

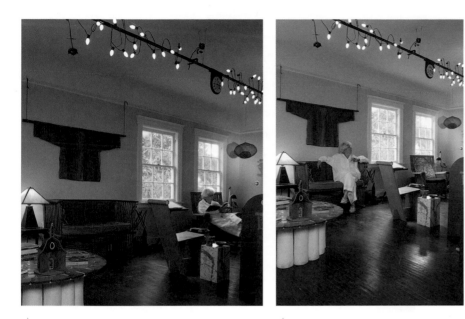

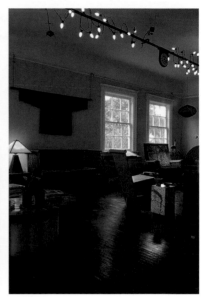

▲ Gere at the window ▲ Gere on the couch ▲ The underexposed empty room.

layers with names that make no sense. I often work with files that contain 50 or more layers. "Let me tell you", (famous saying of my father-in-law, and you must jab your finger onto the table while reciting) developing the work ethic of naming layers with meaningful names will save you scads of time later when you revisit an old file and wish to rework it for resale, the web, or just for the heck of it. I follow this workflow now and it makes my life easier.

The lower **Jacket Group** contains a duplicate of **Base_Image**. It was renamed Chair. The screenshot is on the following page. It is toning everything except Gere and a bit of the bottom of the jacket. Doesn't make much sense now, but then it obviously did. In the top Jacket Group, I toned and highlighted the edges of the hanging jacket. Back then I felt it best to create this effect by applying the **Gaussian Blur Filter** to the entire duplicated layer. By using a **Layer Mask** I was able to control and minimize the blurring to a localized area of the jacket and other parts of the background. A **Curves Adjustment Layer** was the

final component for this effect. Inside the top **Jacket Group** are three **Curves Adjustment Layers**. Two have the attached masks slightly edited. This **Layer Group** was added to further tone and modify the effect as I changed my

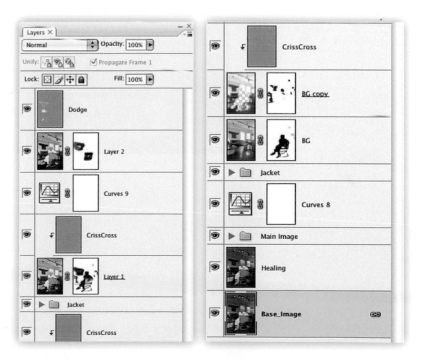

▶

The lower Jacket Group

▶

The top Jacket Group

▶

A detail of Curves 4, the edited adjustment layer mask.

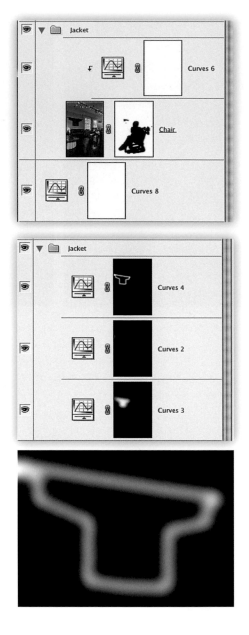

4 is set to lighten all values in the layer. A mask filled with black "hides" the effect of the **Adjustment Layer** it is attached to. White "reveals" the effect of the **Adjustment Layer** it is attached to. Repeat after me, "white reveals, black conceals."

When doing this effect today, in workshops around Southern California and in classes at world famous Brooks Institute, I teach how to use the Lighting Effects Filter on a duplicate layer. This filter effect is then altered with the Gaussian Blur Filter, set to a 4 pixel radius. I use 4 pixels here because the file is hi-resolution. Different resolution files require different radius settings. Experimentation is key. Afterwards I adjust the Layer Opacity somewhere between 30 and 50% and adjust to taste. Save and it's ready to publish.

mind several days after the initial Photoshop session. As I said earlier I'm embarrassed by how unprofessional this layer workflow now appears.

Directly above is a detail of the Curves 4 mask. It was edited (painted) so just the edges of the jacket were affected. This gave the edge of the jacket edge a slight highlight. Curves

René Zendejas

The following tells the story of how I met René and how we ended up collaborating on several environmental portraits.

I am very fortunate and appreciative of the fact that I can connect with just about anyone within the first couple of minutes of meeting them. Early on I realized that while my profession is photography, selling is my business. If my sales presentation doesn't appeal to a potential client, the likelihood of them working with me is smaller than it would be if the sales presentation did appeal to them. It's that simple. Easy concept to grasp; hard to pull off. I've been doing it for a long time, some years better than others. I'm not perfect, .

I introduced myself to René after watching him perform a puppet show at a mutual client's holiday party. There were 150-plus adults in attendance and a couple dozen children, including my young son Nathaniel.

This mutual client often commissioned me to make portraits for print and Web use. After completing another successful project for them, I was invited to bring my family to this social gathering.

The puppet show in and of itself was not very interesting to me, but I was taken in by René's age, costume styling, and professionalism. He was a workhorse. The portion of his performance where he brought out Popcorn (one of his favorite puppets, as it turns out) was inspiring.

During the performance, Popcorn flew in front of and around René while holding an air-filled balloon. The balloon rises and Popcorn tenderly floats aloft. Suddenly the balloon pops and Popcorn falls to the ground. He is embarrassed, gets up, and hides from the audience of children behind René. The way René made Popcorn move and gesture was in-

credibly touching. I was drawn in to his world. Good stuff. I felt an image hit coming on.

René's relationship with Popcorn was riveting, honest, and loving. I just had to meet him. As I was thinking of a way to introduce myself, it hit me. We had mutual acquaintances: Sid and Marty Krofft, the creators behind H. R. Pufnstuf.

As it turned out, I had been in René's shop several years earlier helping Marty edit film from a catalog shoot I had recently completed for them. In 1998 they held an auction and I was the photographer contracted to produce the images for the collector's edition catalog. After the auction, Marty told me how pleased he was with the look and quality of the photography. When you work for yourself, those words are magical! I talk about the catalog in greater detail in the product chapter.

That's how I came to find myself in René's shop. I was there working with Marty because the world of puppetry is small; everyone knows everyone else, and we needed a place to edit the shoot and make our selections for the catalog. Marty knew René, and for

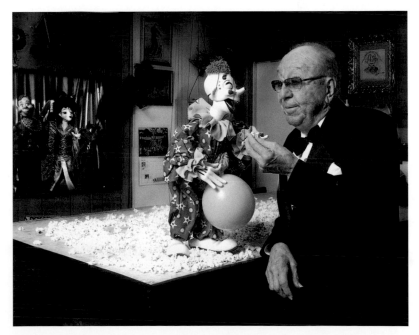

Popcorn and René share a moment in the puppet repair shop while others look on.

reasons known only to Marty, he wanted to work at René's shop. Because of this prior visit to René's shop I recognized the name even though we had never met. Since Marty and René went way back, when I approached René and introduced myself, I asked him if he knew Marty.

René's eyes widened, his eyebrows lifted, and then he let loose. He went on for five minutes about his various excperiences with Marty. Then I shared some Marty stories of my own. This brief exchange connected us and convinced me there was a portrait or two a-waitin' to be made. I asked him if he would consider posing for some portraits. He said yes and the ball was in my court.

The idea to take away from this story: Look for an opportunity, create your own opening, and be ready to jump!

Being a busy, self-employed artist, I wasn't able to set up an appointment for a few months. We finally met at René's office to discuss story concepts, which provided me the opportunity to listen to René's stories. He has a lot of 'em. I was there for quite a while. This time was well spent, though, for it allowed us to develop trust in each other early in the process. This in turn makes for a better photo session and, obviously, a better end result.

Popcorn was René's first puppet. MGM commissioned René to make Popcorn and a back-up Popcorn (2nd kernel) for a Gene Kelly movie produced in the 1950s. After the puppets had been completed, MGM changed its mind. As disappointed as René was, he kept the puppets and has worked with them throughout his successful and interesting career. Back then, puppets were made of poplar, a heavy and durable wood which was readily available. After several decades of lifting "poplar" Popcorn, the rotator cuffs in both of René's shoulders were so damaged he could no longer lift anything above shoulder height. This was useful information to have beforehand, as it informed me as to how much physical movement René would be able to tolerate in terms of posing. Popcorn rarely flies nowadays; he just walks. Today puppets are made of lightweight, durable plastic. Can you say "Mrs. Robinson"?

René has been in the business since the 1940s and here it was 2005. Good, strong storytelling photos of the man were nonexistent. Oh yes, there were plenty of PR photos and production stills, but absolutely nothing that was fit for a man of his longevity, abilities, and artistic nature. This was my opportunity, created by being in the right place at the right time. Mr. Pixel, that's your cue!

In 2005, when I revisited René's studio, I immersed myself in his environment: puppets on stands, puppet heads in cases, awards on the walls, a naked Adam and Eve on a shelf (sounds like a greasy spoon entrée), framed photos, and newspaper clippings. In one corner of his office was a setup where past TV appearances were copied onto DVDs. In another display case were his most elaborate and expensive puppets, including an exact replica of Howdy Doody. The workshop in the back held several puppets in various stages of manufacture: arms, legs, and heads hanging from racks; as well as a band saw, a paint booth, a mold room, and a finish room, all steeped in the history of his career.

I got a great image hit. It practically knocked me down. I next refined my idea to distill alll this content down to the necessary elements.

While I was listening to René, it became clear that he is a multifaceted artist with many funny career stories. He is the tuxedoed

performance artist; the Gepeto-like character working in the back; the sarcastic, wisecracking, shoot-from-the-hip storyteller, always with an eye for telling those stories with humor and salty language. He's a hoot!

Three ideas evolved from my research and image hit. I can't emphasize enough how very deliberate I am at this stage of my creative process.

The artistic process entails taking an idea and working it over in the mind's eye, drawing it on paper, making prototypes, practicing the technique, and applying the results. The artistic process requires years to finesse. It is my creative protocol. For painters, sculptors, writers, and filmmakers, it seems obvious that this process takes time, but photography, with its aspect of instant gratification, often gets overlooked. Sure, the casual point-and-shooter likes to work fast, but for us commercial hounds, we need a process. Professionals sell predictability and control.

Speed and efficiency are eventually incorporated into this process, too, because, let's face it: we're on deadline most of the time. But spending the time up front to conceptualize and research pays big dividends during the shoot.

The Master Puppeteer Ideas

An exercise I engage in when beginning to create is thinking of comparisons, contrasts, and juxtapositions. Big vs. small, cool vs. warm, fast vs. slow, clear vs. confused, happy vs. sad, and so on. This exercise begins the conversation in my head about how I'll tell a particular story.

Idea One: Two Old Friends

René and Popcorn are having a conversation in the costume-finishing and repair room. Both are in costume talking over old times, while Howdy Doody and others look out from a display case longing to be included. Adding a whimsical touch, popcorn is spread on the table where this conversation is taking place.

This idea was inspired by a photograph of Stan Laurel and Oliver Hardy. It was taken of them off-camera between takes. Stan and Ollie are sharing a private moment while enjoying a good laugh. You can feel the emotion, friendship, and bond between them. I first saw this photograph in high school, and its impact upon me was profound. The power of photography is real. If my photos approach this level, I will have accomplished one of my life goals: producing photography people respond to.

I was fond of this idea and worked hard to pull it off. The story idea spoke to me. I felt it in my heart. Shortly after the session, though, I realized it had fallen short. The lighting was inappropriate for the mood I wanted to portray. I also didn't feel René was shown in as flattering a way as I felt was necessary. The camera RAW original and the finished image are on the following pages.

When I use the word "inappropriate" to describe the lighting, I mean that the light and dark areas in the scene were not balanced appropriately for the story I was feeling and wanting to illustrate. I had difficulty working with the physical layout of the room. Some of the props I decided to leave in caused me cropping grief later in postproduction. You're thinking, Why not fix these issues in Photoshop? Good thinking, Grasshoppers. I did just that. I worked on it over and over again, each time

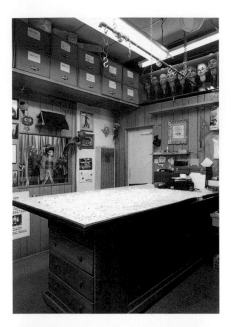

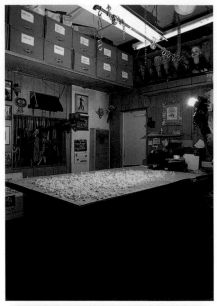

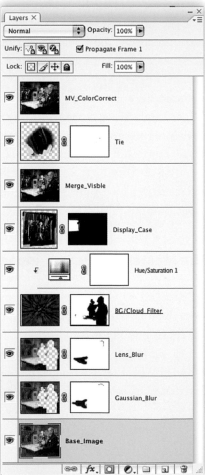

▲
The five RAW images displayed here are just some of the background elements I shot for potential use later in postprocessing. The top middle and bottom left images made the cut.

▶
The Layers Palette from this image: Compare this to the Layers Palette from Gere's portrait and the efficiency of René's portrait becomes obvious.

coming to the image with fresh eyes and new ideas as to what needed to be worked on next.

There were over 40 frames made of René and Popcorn to choose from. I've shown only the "keeper" for the sake of brevity.

Two Old Friends

After carefully using Photoshop to create the mood I failed to capture in the shoot, the photo works for me now.

Photoshop obviously played a large part in paring this story down to its core. Judicious cropping has saved many flawed photographs; don't let anyone tell you otherwise. I work to compose in-camera; cropping is not something I plan on doing, but I'll go there for the sake of clarity. Creating more contrast and saturated colors gives the image the theatrical aspect not obvious in any RAW original. I used a combination of the **Gaussian** and **Lens-Blur**

Filters to guide viewers where I wanted them to go. Adding the lit display case gives the image its final touch. Thank you, Stan, Ollie, and the uncredited photographer who shot the image. Inspiring.

This entire set of captures was lit by a single Canon 550 speedlight. A Sto-Fen diffusion cap for the 550 and a 36-inch silk umbrella were the light modifiers. I used guide-number math (no need for a flash meter) to calculate the aperture by measuring the flash-to-subject distance (FSD), factoring in the ISO setting and the light modifier's effect on the flash power. A thorough discussion of guide numbers and a guide number test follows later in this chapter.

Knowing how to use this information helps me craft photographs in unforgiving lighting conditions. If you can estimate distances with some degree of accuracy, then working with guide numbers is much faster than hauling out a meter, turning it on, setting the parameters,

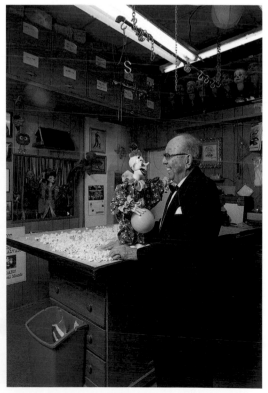

This frame more closely resembles the Laurel and Hardy photograph that was my inspiration. To the right; the camera original.

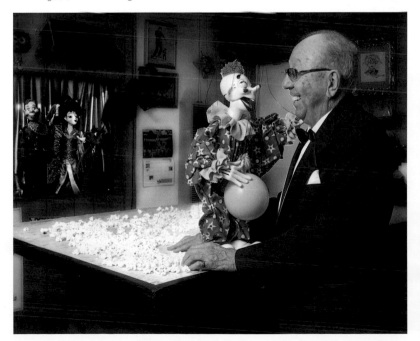

and firing the flash to see what aperture the meter has calculated.

Work and Play

Idea Two: Work and Play

René wears a tuxedo and stands in the middle of his workshop while his workers buzz around him. They are blurry, he is not. He stands in the middle of this scene going through various poses that I direct. The idea is to contrast his performance persona with the grunt work behind the scenes. Classy, yet fun.

The original idea of René in a tux with his employees moving about him in a blur morphed into René as Gepeto, sitting at his workbench fussing over a puppet head with his people working in the background. I added several puppets on a rack immediately to his right to further convey his father-like stature to this brood of feathers, strings, glitter, and resin. Popcorn is, of course, in the photo.

How was this image put together?

Camera position, lens focal length, aperture, color, and lighting were the critical parts of this image. Aren't they always? They had to work in concert in order to show as much of

The finished composite contains 25 layers.

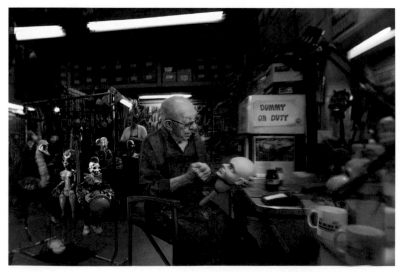

the environment as possible without sacrificing the idea.

The way I shot *Work and Play* was a direct result of making the portrait of Gere Kavanaugh in 2002. I had wanted to revisit that multi-image process since 2002 and apply what I'd learned since then.

In my approach to photographic storytelling, image planes, or layers, are crucial components. The foreground must relate to the middle-ground, which in turn relates to the background. For me, this ensures that story ideas and picture elements (subject and props) tie into each other. I try not to have fluff in my photos; everything in my photograph is there to serve the needs of the story. Even if the foreground is empty, it is still present and must be reckoned with in my mind and must be accounted for in the composition.

For René 's photographs, the image planes, or layers, are crucial components. I set the chair in the foreground, the puppet rack in the middle-ground, the employees in the background, and the other props were placed in their specific locations.

The first order of business was to photograph René doing his thing with the puppet head. There were 23 exposures made of René. I directed him into a variety of poses and attitudes that I felt were important. Upon completion of this portion of the shoot, my assistant held the chair while René carefully slipped off and left the scene. This image was done bouncing a Canon 550 speedlight into a 36-inch white silk umbrella. Check out the first panorama on the DVD and you can see where the light was positioned without the umbrella.

Next, my assistant (the ever-engaging and always helpful Pat Swovelin, who, by the way, made the panoramas in this book) and I made the rest of the exposures. As I stood at camera, Pat (with speedlight in hand) worked his way

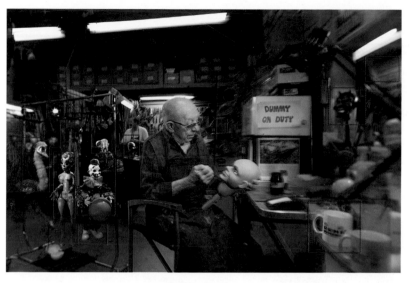

The red squares indicate where the Canon 550 speedlight illuminated the rest of the set. Additionally, 18 ambient light exposures were made. The people were asked to leave the scene prior. Several of these "blanks" were added to the scene and specific sections were painted in to keep the file from getting too dark for reproduction and to enhance the overall effect of this story.

around the floor as directed by me. Using Pocket Wizards, I triggered the speedlight. By knowing the guide number of the flash at any given ISO and making note of the FSD, I was able to predict the correct aperture for the ISO selected. Pat pointed the speedlight at the subject and at the correct lighting angle, and I fired it off. A total of 55 separate exposures were made using this procedure. If I had chosen to light the scene as a one-shot deal with many lights, I would have spent a full day rigging, hiding cables, and making compromises due to the architecture of the building. I don't like making compromises in my photos if there is another way. Digital gives me this other way. The Photoshop file contains 25 layers, unfortunately too numerous to show here.

I'm able to light up an entire scene with a single flash unit fired multiple times. With a locked-down camera on a tripod, I am able to create the stories I want to tell. It still takes work, but I'm much more successful working with digital.

Each of the three puppets was lit four times, three on various body parts and once for a hair light. The four puppet heads at the back of the set were lit the same way. The devil on the

right, the coffee mug in front, the face of the worker next to the ostrich head—all were lit with a single light. For fun, I also had Pat point the light right at the camera. Look above the worker near the ostrich head again. Once the distance was established, zoom head settings checked, filter factor of the diffusion cap calculated (plus one stop), it was easy using guide-number math to set the appropriate apertures. I varied the aperture settings instead of changing the shutter speeds because flash exposure values are affected by aperture changes, not by shutter speed changes. The aperture changes caused the depth of field to vary but this was a calculated effect and I was fully aware of the results and of what I was going to be working with in post. This created strange layers of in-focus and out-of-focus areas, further adding to the depth of this portrait.

Take a look at the image without René (captioned "The primary setup"). Note the blurry objects near the right edge. Compare the lamp head and the devil bust with the image at the top of page 20 (captioned The primary setup). This was done deliberately, using a 24 mm perspective-shifting lens, to create edge-blurring, which enhanced the dream-like

quality of the story. This is an example of using a tool for something other than its intended purpose. After the exposures with René were completed, he got up and left the scene. The lens was shifted to create a blurred edge and I made additional exposures, varying the amount of blurring prior to each set of captures. Know the rules, then strive to break and reset them to your advantage. My background

in film trained me to get it right at the moment of exposure. I knew what I wanted and knew I could do it at the time of capture. No problem. I have to do things in a way that resonates with my way of thinking about the photographic artistic process. If I don't, I'm not being true to myself, my vision, or my audience.

OK, but why not do this step in post? Good question again, Grasshoppers. Here is my

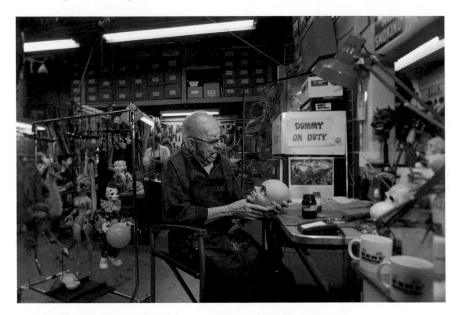

▶ The primary setup.

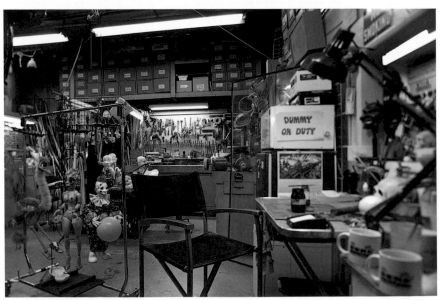

▶ After the focus shift.

answer: Some steps just work better live. It is the smart photographer who decides what can be done in post and what must be done live.

I often refer to being classically trained in photography. I worked with film and darkroom techniques from 1979 to 2001. I rubbed developing prints with my fingers coated in toothpaste to bring change to a print, all the while wearing white plastic aprons and big yellow gloves. I exposed and lit correctly at the moment of exposure. My training compels me to get it right up front and use Photoshop for the very specific tasks that are easier to complete in post. I like to get it right when I

shoot. I know what I'm doing with an image to ensure that it will reproduce correctly with the chosen ink set, paper, and line screen.

As I mentioned earlier, we made 55 exposures of the scene with a Canon 550 speedlight. Each object in the scene was lit as if it had three to four lights illuminating it. I also made eighteen exposures of the ambient light in the scene to use as a base for the image. The empty-room exposures were made to ensure that I had a foundation image to the photo composite I was creating. Having this base without any subjects or additional lighting in it allowed me to paint in specific areas to

Here are a few of the captures, with and without René. Look closely and you'll see the light moving around.

help enhance the overall effect. All part of my plan. As I mentioned earlier, this composite contains 25 layers.

This technique of shooting ambient light only images of a particular scene is similar to recording "wild" or ambient sound on a movie set. This ambient sound is then blended in with the actors previously recorded dialogue, the end result being a more believable scene.

The other rule I broke was frequently changing the exposure value, either by changing the aperture or by moving the flash in or out to adjust the brightness value of the scene. Aperture changing created layers with varying degrees of depth of field, and this technique added depth to the portrait. I love the effect of focus shifting. Total time from when we rolled up to when we wrapped out of René's workshop: 90 minutes. Ninety-six captures,

one light, and lots of process. We made more exposures than ultimately would be used. It is better to have it and not need it than need it and not have it. If I had used film, the time for lighting alone would have been at least half a day. The cables on the floor would have to be hidden or strung from above. The color temperature issues associated with film would have required filtering lights and/or the lens more than once, or employing a medium or large format camera multiple-exposure technique. Can't forget about the cleanup that goes along with the old ways. Waiting for the film to be processed. Other inevitable compromises. It goes on and on with film. I'm so glad to be working with today's technologies.

Film is dead. OK, not dead exactly, but really, really tired.

▼

Check out this unfolded panorama, as well as those from other sessions. View the companion DVD to see it correctly. It is in the folder named "Panoramas". Thank you, Pat.

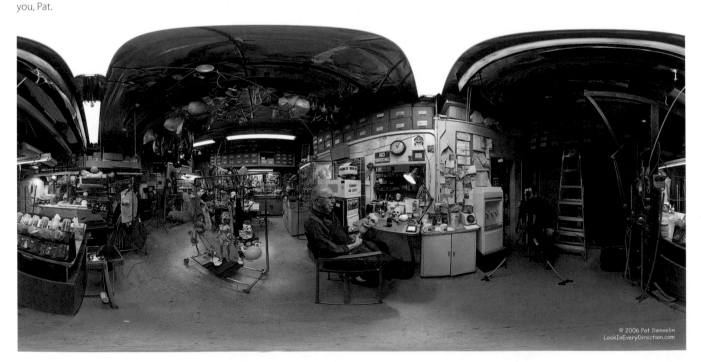

© 2006 Pat Swovelin
LookInEveryDirection.com

The Guide Number Test

A guide number (GN) is the numerical expression of the power of a small camera-mounted or hand-held electronic flash unit known as a speedlight. Regardless of the stated guide numbers, professionals perform a guide number test to accurately measure and understand what the GN is for each speedlight unit and camera combination they work with.

The guide number calibration test is simple to perform and provides valuable information for photojournalists who routinely have to

GUIDED NUMBER THEORY

Guide numbers are calculated using the following equation:
Guide number (GN) = flash-to-subject distance (FSD) x the aperture setting (f/stop)

There are two derivatives: FSD = GN / f/stop, and f/stop = GN / FSD

Use these parameters when performing the GN test:
- ISO: 100
- Zoom head setting: 50mm
- Speedlight: operating in full manual power
- FSD: exactly ten feet
- Camera sync speed: the maximum shutter speed your camera will synchronize with flash without using the "high-speed sync" setting ∎

THE TEST

1) Point the flash unit at a human subject exactly ten feet away.

2) Make sure the subject is wearing a white tee shirt.

3) Make sure the room is dimly lit. The ambient light should not contribute to the exposure value.

4) Place either an 18% gray card or a Macbeth Color Checker in front of the subject.

5) Change the exposures by altering the apertures and not the shutter speeds.

6) With the camera set to the correct sync speed, make a series of exposures beginning with f/22 and ending with f/8.

7) Open the aperture in 1/3-stop increments. There will be ten exposures when completed. ∎

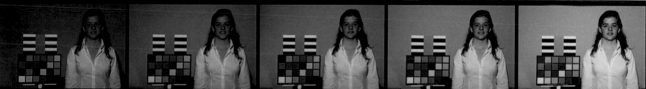

GN_Test0901.JPG
1/200 s at f/22.0, ISO 100

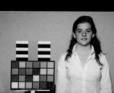
GN_Test1002.JPG
1/200 s at f/20.0, ISO 100

GN_Test1103.JPG
1/200 s at f/18.0, ISO 100

GN_Test1204.JPG
1/200 s at f/16.0, ISO 100

GN_Test1305.JPG
1/200 s at f/14.0, ISO 100

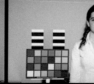
GN_Test1406.JPG
1/200 s at f/13.0, ISO 100

GN_Test1507.JPG
1/200 s at f/11.0, ISO 100

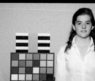
GN_Test1608.JPG
1/200 s at f/10.0, ISO 100

GN_Test1709.JPG
1/200 s at f/9.0, ISO 100

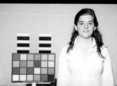
GN_Test1810.JPG
1/200 s at f/8.0, ISO 100

create images under difficult lighting conditions, and helps photographers who choose to make lighting ratios with multiple speedlight units.

Evaluating the Results

Open up the two or three images in Photoshop that look correct. Set the color picker to 3x3 or 5x5. It is now simply a question of selecting the image with the best "white with detail" numbers. The highlights in the white tee shirt should fall between 247 and 250 to ensure a print with detail in the highlight areas. Highlight output numbers are specific to printer, paper, output resolution, and ink combinations. This isn't a book about digital printing but know that profiling, experience, and testing determine the exact number. That being said, select the highlight area where you wish to hold printable highlight detail.

Evaluation of the subject's skin tone is also an important part of this measurement process. Skin tones vary, so strive for a balance between white-with-detail numbers and skin tone values. This step is a mixture of experience, taste, and science.

It is highly recommended that a gray card or Macbeth Color Checker be included as part of this test. Measure the gray card and look for an exposure value where the middle gray number is in the 130-140 range. Depending on the manufacturer this number can go as high as 180! There are huge inconsistencies using gray cards and digital capture, so use the gray card more for color correction in post rather than density correction. Also, if the gray card is not parallel to the camera when shooting this test, the light striking the gray card at this off-angle will cause flaring, which in turn will throw off the numbers. You'll have better luck with a Macbeth Color Checker, but take note that its middle gray is around 110.

As long as emphasis is placed on white-with-detail numbers, followed by skin tone and then middle gray values, an optimum exposure will be identified.

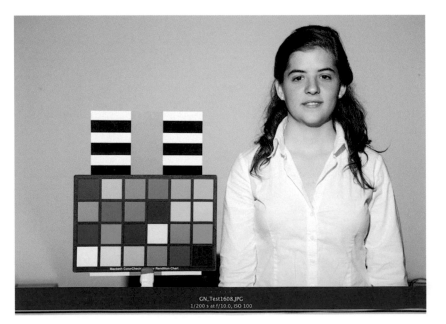

This exposure contains the detail I look for in skin tones and highlights.

Finishing Up

To better illustrate this concept, a frame will be selected and plugged into the formula. The selected frame is f/10. It has the white-with-detail number range and good skin-tone values necessary for reproduction. When the GN formula is applied to this number, an accurate GN for the particular flash unit and camera combination is achieved: f/10 multiplied by ten (feet) results in a GN of 100.

The GN is also affected by the ISO. As the ISO changes, so does the GN. It works like this: If the ISO increases by one full stop, from 100 to 200, then the GN increases by a full stop. If the ISO decreases by 1/3 of a stop, then the GN decreases by 1/3 of a stop. The GN tracks the aperture scale so it is easy to follow. For example, if ISO 100 goes up to ISO 200, then the GN goes from 100 (f/10) to 140 (f/14).

In this example, as the ISO decreases from ISO 100 to ISO 80 (a 1/3 stop change), the GN decreases from 100 to 90, a 1/3 stop change. You can locate the GN by using the aperture scale. Multiplying the chosen aperture number by ten will provide the new GN. There are rounding errors with this method, so round up or down to the nearest number that when divided back into by ten, is an identifiable aperture number. Because the power of speedlights is absolute, darker subjects will probably do better by rounding down; lighter subjects will probably benefit by rounding up.

When only the FSD is changed, the speedlight becomes more or less powerful. When the FSD is decreased, the speedlight becomes more powerful; when the FSD is increased, the speedlight becomes less powerful.

For example, if a GN is 130 at 200 ISO, then your aperture is f/13 at ten feet. If the flash is moved towards the subject from 10 feet to 7.1 feet (one full stop), the flash has become one stop more powerful.

If the same exposure value is to be maintained at this new FSD, then the lens has to be stopped down to f/18 to properly compensate for the closer and more powerful speedlight. Beginning to see how this works?

If the speedlight is moved back from 10 feet to 11 feet, the flash output has dropped by 1/3 of a stop. Open up to compensate for this drop in output from f/13 to f/11, a 1/3-stop difference.

In conclusion, a GN is the mathematical expression of the power of small flash units called speedlights. The GN is the aperture number multiplied by ten. When a camera's ISO is changed, up or down, the GN follows in lock-step, up or down. The GN can be increased or decreased by moving the speedlight closer or further away from the subject (FSD).

For those with a flash meter, take a ten-foot measuring tape or a string and have your subject hold the flash meter at his or her nose while being at one end of the ten-foot marker. Fire the flash from the other end. Multiply the number that shows up in the LCD panel by ten and that is your GN. Assuming, of course, that the flash meter is calibrated correctly. Oy! Another test! Go with the first GN test and forget about the flash meter.

Armed with the knowledge that my speedlight's GN is accurate, I'm ready to create anything.

Qualities of Light

Emotionally stimulating light is essential to the creation of outstanding photography. By categorizing light, one can begin the process of seeing light as a tool of photography. Think of light in these two categories: Formative and Comparative. The Formative category includes

light direction and whether the light is direct (specular) or diffused. These qualities form the foundation of an image and are not easily (or convincingly) altered in post-production. In fact, if you have to try to change them in postproduction, you probably made an error when you shot the photo. Spend time to dial it in beforehand and you'll minimize stress and frustration down the road. You know the old saying, "measure twice, cut once" and that sort of thing. If I have my hands full with masking, blending edges, filtering, and such, I don't want to increase the degree of difficulty by dealing with photographic issues that weren't correctly done in the first place.

The Comparative category includes color, contrast, and brightness (key). These subjective aspects are easily and convincingly changed in post-production. In fact, if you're not making some changes to these particular light qualities, then your image is probably pretty dull, especially when shooting RAW captures.

Tables Turned

Light, gesture, color, and expression are the markers for communicating the story of this image.

The DVD contains bonus material about this image. Look under "Tables Turned".

After successfully completing the shoot with René in his studio, it was time to move to my studio. I worked out the concept through my dreams. You know the expression, "In your dreams"? Well, that's how I often work. I sit on the edge of the bed with a notepad, pen, and clock nearby. I close my eyes and, before getting under the covers and putting head to pillow, I have a conversation with myself about what the goal of that night's dream is. We (me and myself) review the important ideas that we will try to resolve during the night. An outline is formed and responsibilities are handed out. In my world, there's no room for slackers.

This may sound a bit odd at first but I assure you this ritual allows my mind to prepare for the journey ahead. If I don't have a plan, a goal, and an outline describing this goal, how will I know when I've completed the journey?

Before your eyes roll back too far in your head, look at the images I create. This is my process. I embrace it. I work hard at it. It works for me. I encourage you to find your own process. Creative people understand the need for a process but may lack the courage or discipline to practice it on a consistent basis. It takes a mixture of self-love, confidence, and maturity to successfully navigate through the inevitable

▼

Tables Turned

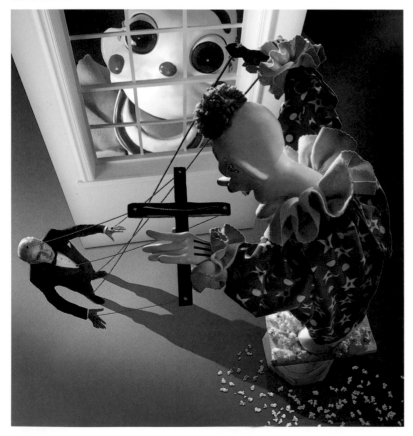

pitfalls and career arcs of creativity. Find your strength to power through the setbacks and frustrations.

So I go to sleep, I dream, I wake up, and I write down ideas. I review, refine, sketch, review, think, imagine, sketch, review, and finally get to a point where I can talk with my subject about the story I wish to illustrate.

In René's case, he likes it. I like it. We set a date.

On the day of the shoot I meet with my assistant Pat an hour prior to René's arrival. I've broken down the shot into its components.

Here's the list:

- Component one: René in tuxedo
- Component two: Popcorn on pedestal
- Component three: Popped popcorn scattered about floor
- Component four: Window flat
- Component five: Close-up of Popcorn's face to be placed behind window

- Component six: Control wires from Popcorn to René
- Component seven: Floor, or foundation, of this image

Whatever component is being photographed, it must be shot on a contrasting background to ease the masking process. All I can say here is: The best-laid plans... Oh well, making mistakes is part of the process. So is pressure. I love how it makes me react to the spontaneity of the moment!

The first step was setting up and photographing Popcorn. The three captures below were blended together for the final image. The red circles highlight the additional lighting that was added during each capture to create more texture and depth, helping to move the viewer around the image.

I made a decision to have a roving light (with a grid spot attachment) move around the subject as a supplement to the base

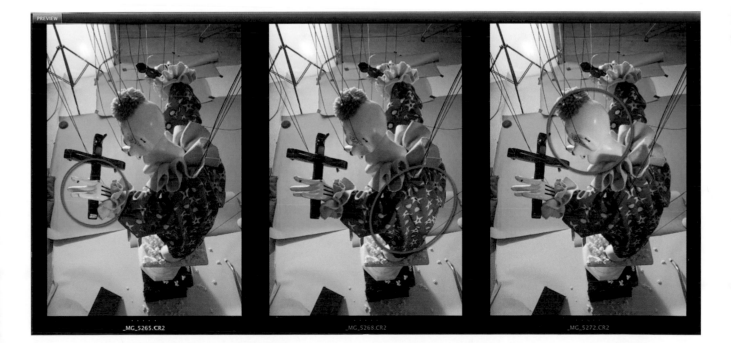

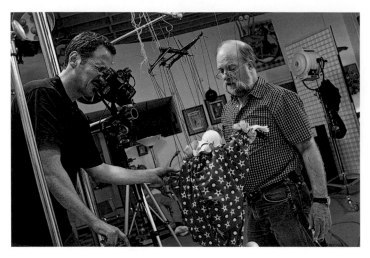

▲
Working out some issues while Pat looks on excitedly.

lighting. I directed another assistant to cross-light specific areas. I chose this method because it made the process of adding these lighting touches faster and frankly, more fun. We actually made many more than these three, but these are the ones that worked best.

I should have had the entire floor as a blue background. I messed up and thought a warmer background would work just as well. Hey, what can I tell you? I'm creative.

▲
Can't go wrong with Jiffy Pop.

◄
Our hero René. "Look Ma, no feet!"

▶
"Ah, there they are!"

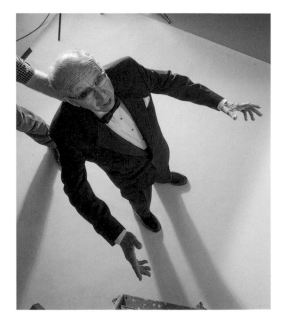

Component two was some popcorn scattered on the floor, shot from the exact same camera position that Popcorn was photographed. This is essential to match up the perspectives without guesswork. I strive to be efficient when shooting and efficient in post. Time is something you can't retrieve once it's spent.

Look closely at René's feet in the left-hand image—they are barely visible. This problem occurred because of René's age and stiffness, as well as the camera angle and focal length. This issue had to be resolved, but how? At Pat's suggestion, I had René stiffen up as if in rigor mortis and then lean back into Pat's waiting arm. This enabled René to lean back at just the right angle, keeping his torso straight and upright, allowing his feet to show. This was the pose René had to be in for the concept to play out. The three of us working together came up with the idea. This was an important visual problem to solve. Not solving it would have necessitated a lot more postproduction effort. I am grateful when the personalities of

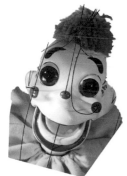

my subjects and assistants mesh; it minimizes getting knocked off-kilter, and I don't fancy making my creative process any harder than it needs to be. I knew what story I wanted to tell.

Window flat

Popcorn's portraits

A close-up of Popcorn and the clone layer that hides the wires.

The soft-edge contact shadow to help connect the wall flat to the floor.

I knew how to get there. I just needed a little help from my friends. Thanks, Pat. Again.

When I'm working, I let myself explore other directions, just to see what may lie in another area of my mind. This takes up time. When it's a project for my portfolio, time is spent, whatever the cost. I logged 36 hours in postproduction to put this environmental portrait together. Five hours were spent just on opening, closing, saving, and waiting for filter effects to render. Creativity is a contemplative endeavor.

Components four and five were the window flat and the close-ups of Popcorn. In the final image, I created a contact shadow between the window flat and the ground. Contact shadows are necessary when compositing objects. In this case, it was done so the window flat would appear to be touching the ground and not floating above it.

The contact shadow layer is shown above. It is simply a grey line painted onto a separate layer below the window flat. When compositing, objects have two shadows. One is a contact shadow made when one object is in contact with something else, usually a floor, wall, or another object. The other is the cast shadow created by the light source. It can have distinct or soft edges, depending on the light source (specular or diffused) casting the shadow. Be mindful when working with shadows; they will help you produce believable composites.

Last, we have the floor and the wires. The wires and the floor were added post-capture. Creating these effects afterward was easier than trying to capture the elements during the actual shoot.

The postproduction cable effect.

The floor was created by putting a new, empty layer at the bottom of the **Layers Palette**. It was then filled in with black and a diamond gradient from black to white was applied. I added some **Gaussian Blur** and a little **Noise** (2%, monochromatic), dodge selected areas, and added hue and saturation adjustments via an **Adjustment Layer**.

Sounds like a recipe, doesn't it? Well, it is. But it's flavored to my taste. Take these ideas, tweak them, and make your own special recipe. It's exacting work and takes way more time than you can imagine. Perfection is the goal, patience is your ally.

On to the cables. Notice how some of them are slightly bowed? Given the length of the wires and the forced perspective of my image, I bent them to give the sense of weight that wires of this length would have. In Photoshop,

Base image for "Tables Turned."

Another one of Pat Swovelin's wonderful panoramas.

go to **Edit > Transform**, and utilize the warp command located at the top of the screen. This allowed me to create the appropriate bowing.

Some of My Professional Protocols

Put forth the effort to find your own path and make a workflow management system that works for the way your brain processes information. That is the key: does it work for you? If it makes sense, do it. If not, change it. Don't be swayed by someone else's must-do process. At two in the morning when it ain't going so well, you'll be the one dealing with it.

Creativity is a fickle thing, and if your muse is working overtime, so are you. Be organized. Have a place for everything and everything in its place. Your muse will thank you.

Control and Predict Output Color

I absolutely, positively calibrate and profile my monitor. As of this writing it is seven years old. I calibrate every two weeks and also right before a client or portfolio edit session. This is standard procedure for me. I do not waver from this protocol. I trust what I see on my monitor. The prints I produce (regardless of the paper surface) are highly regarded. Trust in the power of color management and learn how to apply it consistently and the quality of your work will improve dramatically.

If you do nothing else with color management, calibrate and profile the monitor. CRTs are still best, but LCDs are getting better and are rapidly replacing them.

X-Rite has the Color Munki, which is a terrific all-in-one color management tool. Profile your monitor, projector, and printer with this Munki. Datacolor has a great monitor calibration tool called the Spyder. I have used both systems; they are accurate and easy to use.

As stated previously, calibrate the monitor, religiously. Spend the money and the time. The results are worth it. And it is the professional thing to do.

I use the ProPhoto color space because it matches up best with the camera sensor's capture information. I want to work with as much information as possible. Adobe 98, sRGB, and Colormatch all limit, to some degree, the information from the camera's sensor that ACR is able to interpret in processing RAW files. Even though inkjet printers and halftone printing (CMYK) severely shrink the color gamut present in Photoshop files, I would rather work in a larger color space, which in turn gives me flexibility in what ultimately appears on screen and in print. I want to manage it for the benefit of my stories, for my audience's emotional response to my stories, and for my sensibilities as an artist. This is professional territory we're in right now. It may seem overkill to the uninitiated, but to us creative professionals it is about choice, control, and predictability. On the companion DVD are several presentation/tutorials. View "Intro_Digital_Imaging" to learn how I pick specific file resolutions for output.

Production Workflow

Working with my pre-visualization techniques, drawing from my experience, and using today's digital imaging equipment to make portraits that otherwise might not get made by me is what makes photography fun and exciting again.

- **Step one:** Download files to computer/add metadata/rename files.
- **Step two:** Categorize files into subfolders and rank them using a star system.
- **Step three:** Process the selected files into 16 bit pro-photo hi-res images.

The tools I used to assemble *Tables Turned:*

- **ACR**—to process the camera RAW originals
- **Layers**—to manage file content
- **Layer Masks**—to blend edges of layer information
- **Adjustment Layers**—to set, control, and edit color and tone values
- **Filters**—to affect texture
- **Clone/Heal**—to retouch flaws
- **Layer Opacity**—to control results for believability
- **Layer Styles**—to add personal taste and to blend edges
- **Blend Modes**—to enhance the overall effect
- **Layer Groups**—to manage the layer palette and bring organization to my creativity

From Camera to Computer

Using Photo Mechanic as camera files download, I add copyright metadata, captions, keywording, and file renaming. There are other software applications from Apple and Adobe that perform the same functions. Very efficient. The next step is to duplicate this folder onto a backup hard drive. SEASO—Save Early and Save Often—to minimize issues when your computer crashes.

If by chance you reformat the capture media by mistake before downloading the files to your computer, don't worry. The File Allocation Table (FAT) is a directory file on the media card the camera generates. The camera uses this FAT directory to keep track of files written to the card. Reformatting updates the FAT but does not erase the files. The camera thinks there are no files on the card, but they're there.

Using an image rescue program locates the data that is still on the capture card.

Use Klix, found at www.joesoft.com, or some other program to locate and recover "missing" files on the capture media and copy them to a hard drive. As long as you haven't used the card to capture new images, you should be 100 percent successful in the recovery process. Even if you have used the card for new captures, file recovery of old files is still possible. I don't leave home without this software on my computers and flash drives. It came in handy when, during a ten-day shoot in Mexico, I reformatted one card before transferring the files from a day's shooting onto my laptop. I was soooo happy when the files were recovered.

Think of this particular screw-up as the initiation into a nonexclusive club with lots of members. Do yourself a favor and have the solution already in place. You're welcome.

The names I give my files usually include the project or subject name, file number, and file extension. This system makes for long names, but it works for me.

Computer Organization

Since composites have multiple image components, I try to categorize the various files into separate subfolders. I create a master folder, named "O", for camera originals, as well as a folder named "Selects" for the ones chosen to composite, a folder named "Working" for the layered psd files, and finally one named "Print Me", or "Delivered", indicating files that have been completed. I usually have multiple working files within the "Working" folder. These files are copied to an external drive. If they are really crucial, a DVD is burned, and I may also archive online.

The files in "Print Me" and "Delivered" are flattened versions of the files in "Working". Often,

"Delivered" indicates a file ready to be sent to a client. The fully layered psd files which I archive take up gigabytes of storage space. This is an inexpensive way to save my creativity and go back to the past anytime in the future to create a new version. I call this the "3F file" or "flexible file format". It allows me endless edits because everything I need is there just waiting for me to change my mind. **Adjustment Layers**, filter effects, sharpening layer, softening layer, and the all-important **Merge Visible Layer** are there, waiting for me to call upon them. If you are not familiar with the **Merge Visible** option, you will be. Invoke this command when you want to make a composite layer of all layers or just selected layers in a given file. It merges only layers with the "visibility eyeball" turned on while keeping all layers separate and intact. This command is most often used when I want to sharpen the combination of what I've created, but it is useful in other ways also. The command is: Shift + Command + Option + E. If you're using a PC, substitute Control and Alt for Command and Option. This is a great technique to master and use. A lot of pros use this technique to make a sharpening layer that can be either thrown away after printing or saved with the file and edited for future output requirements. I use both techniques.

Production

Sometimes I'll make small jpegs so I can make quick, loose composites to see if my selects were the correct choices. Why not make jpegs (along with RAW, of course) during capture and use them to save time? It's a personal choice. The fact is you'll get more accurate color, contrast, and density if the jpegs are generated from the RAW files. Even at this early stage, I want to work with files that are close to final color and contrast. I usually have

the end result in mind, but I always leave open the possibility of being inspired by the process and by how my emotional reaction to my images changes. This is a good thing, a very good thing. Even with an end point in mind, I'm aware of the creative gremlins floating in the ether that affect me during this delicate time. I like—better, I embrace—variation, randomness, and the unknown. I frequently measure the projected end result against where I'm currently at in an environmental portrait or composite. Good gremlins or not, I want to experience them to the fullest extent during the pursuit of my creative endeavors.

Once I've worked out the major issues, the real fun begins.

The RAW files are processed by Adobe Camera RAW (ACR) into 16-bit, ProPhoto files. They are then enlarged to the maximum size I can get at 360 ppi. I also make them Smart Objects. These 144-megabyte files will print at 11x17 inches at 360 ppi. These layered files are huge. A file in excess of two gigabytes is not unheard of. *Tables Turned* takes up almost a gigabyte when saved to a drive and opens up at over two gigabytes.

Miscellaneous

During the film days at my studio, I kept the flash meter in my equipment cabinet. When I was ready to meter the lights, I had to go to the cabinet and get the meter. The time I spent walking to the cabinet to retrieve the meter and back to the set gave me time to think about what I was trying to do and if it was worthy enough to try as a solution for the creative issues before me. While I wait for these huge files to save, it gives me time to make notes about the image and whether or not it is going in the right direction.

I use whatever gets me to my goal of making the portrait work. The work habits I developed during my film days serve me well in this digital age. I've met a number of young, new photographers without a film background. They have a hard time grasping these ideas and work habits. There are definite benefits to having learned photography in the pre-digital era.

For *Tables Turned*, Photoshop obviously played a major role. Photoshop was called upon to help me realize my vision. That need, however, did not relieve me of the responsibility of making thoughtful, prudent decisions while shooting.

Bonus Round

Sam Maloof

Sam Maloof was a master woodworker. He lived to be 92 years old. Good-bye, Sam; you're now with Alfreda. Known the world over for his rocking chairs, he was a generous and humble man. I met him in 1998. He had a one-man show at a gallery in Beverly Hills. I was hired to scan, enhance, enlarge, and mount a mural-size print from a black and white film portrait of Sam. It was displayed at the entrance to the gallery. As part of the opening festivities, he gave a speech about his work and life. His confidence and mannerisms were inviting. I never forgot that evening or meeting him.

Flash forward a decade. I was invited to tour his foundation with some teaching colleagues. During the tour, I went up to him and reintroduced myself. We talked briefly about that evening. During the drive home, I became overwhelmed with a desire to make a portrait of him unlike anything previously done. Sam has been photographed time and time again,

It was this snapshot taken on the tour that led to my image hit of Sam.

but the images were all basically the same. I wanted to do something different. A week later I sent a request letter and a package of six portraits with the hope they would persuade him to sit for me. I rarely pass up an opportunity to practice my letter-writing and packaging skills. If you want to be a virtuoso, you have to practice your scales. I practice a lot. It worked.

Because of his steadfast support of artists, he probably would have said yes anyway with just a phone call. If felt great just the same to have him accept my request through correspondence. Follow me now as I walk through preproduction, production, and postproduction.

During the aforementioned tour, I had my camera with me and made lots of images of the grounds. Sam has two warehouses on the grounds stocked with about a million dollars worth of inventory. One of the warehouses has a supply of Ziricote wood from Mexico. It has a beautiful grain and I shot a couple of photos of it. While reviewing the files, I got my image hit. Why not put Sam here and make him one with the wood? Very Zen-like. Very Sam-like.

Bingo! That was the direction this portrait was going to take. Better yet, have him stand on the baseboard, lean into the stack, and really become part of the wood? Bingo again! One more bingo and I win. I e-mailed to set a date. We were on!

Preparing Gear

My preparation includes thinking about equipment, assistance, cost, lighting, mood, time, and subject direction (Will the subject do what I want?).

One great thing about having a photo studio is the equipment one accumulates over the years. One of the worst things about having a photo studio is the equipment one accumulates over the years. When I had a location assignment, it was a pain deciding what gear to take and how to transport it all. Solution? Bring as much as possible, in a big vehicle. I loved it and hated it. The experience included gathering gear together on the studio floor, checking it off against the production list, loading it in a vehicle (an art form in itself), traveling to the location, unloading,

setting up, shooting, breaking down, reloading the vehicle, traveling back, stopping off for a drink, unloading, checking it off against the production list (for lost or damaged gear), putting it away, and collapsing. I now shoot with an "equipment-light" approach. This has as much to do with my age and stiff joints as with digital capture minimizing the need for so much lighting equipment. Have I told you how much I love digital?

Since May of 2003, I have been adjunct faculty at Brooks Institute's Ventura, California campus. In the Visual Journalism program, I teach advanced Photoshop, pre-press, digital printing, and lighting with speedlights. As faculty, we teach an equipment-light approach to working in the journalism field. Especially gratifying for me is teaching how to light a location using ambient light and a speedlight (or two) used in automatic or manual mode. I have embraced this equipment-light approach and now travel to most jobs with a rolling Lowepro case and a duffle bag with a few stands and umbrellas. It is amazing what you can accomplish with a minimum of gear, combined with knowledge, passion, and confidence in your own expertise.

As we began setting up for Sam's portrait, my assistant Jacalyn was incredulous when I told her that all I had brought were three bags: a camera bag, a stand bag, and a miscellaneous-clamps-and-gels bag. The look on her face said she had serious doubts about how much could be accomplished with so little gear. In the past, I would have doubted too.

I select my assistants based on the personality of my subject and how much I trust my assistant not to say too much or too little too often. They must be mature, have good hygiene, and love photography and lighting. Most importantly, I must like them.

I spend time imagining the end result first. Once I get a clear picture of this, the process of deconstructing the image begins. Questions flash in my mind: What is the mood? Light? Happy? Serious? Where is the light coming from? What is the lighting contrast? What is the color of the scene? How will I direct the subject? What type of paper do I imagine this portrait being printed on? What if my requests for posing are refused? Is there a "Plan B"? Some of these questions have already been answered. I look upon this ritual as a review before the session begins. Things change, my mood changes, the subject is nervous, etc. Be flexible. Stay frosty. Be ready to react to new feelings.

I am an experienced and capable photographer. I come back from assignments with successful images. It is my passion. It is my profession. It is my job. This does not, however, prevent me from getting butterflies before, during, and after a shoot. It's a feeling I embrace, because it connects me to something deep in my soul and helps sort out who I am and what I'm about. I truly believe this is a fundamental part of the creative process. I live for it.

The Shoot

Flexibility and commitment to the process are necessities. Having a planned approach to the process of creating a series of lit components to be assembled into a cohesive whole is essential for producing successful composites.

I pick the camera position, then the focal length and aperture. My camera is secured to a very sturdy 28-year-old Gitzo tripod. After spending time sensing the ambient light levels, I decide on the mix between this ambient light and the speedlight. Once this is calculated, I shoot a color slate to have a record shot of the ambient and speedlight color mixed together.

This important step helps me begin the process of deciding the appropriate color balance for the finished piece. I shoot in RAW so the camera essentially does nothing other than record information and send it to the media card. RAW equals QUALITY. Say it again, RAW equals QUALITY.

It took a while for Jacalyn to buy into my idea. It can be frustrating when your assistant questions your ability and your sanity. Creativity is a funny thing. Sometimes very clear, but it can often be cloudy and frustrating. Some of my process involves speaking to myself. I have conversations with myself, and sometimes this gets misconstrued into others thinking I don't know what I'm doing. But it's how I create. It's my process. I do not apologize for it. If I feel it helps the situation, I'll explain myself. I may not always know how I'll get there at a particular moment, but I do know I'll arrive and deliver. Twenty-five plus years tells me that. So does talking out loud. After the shoot, I thank

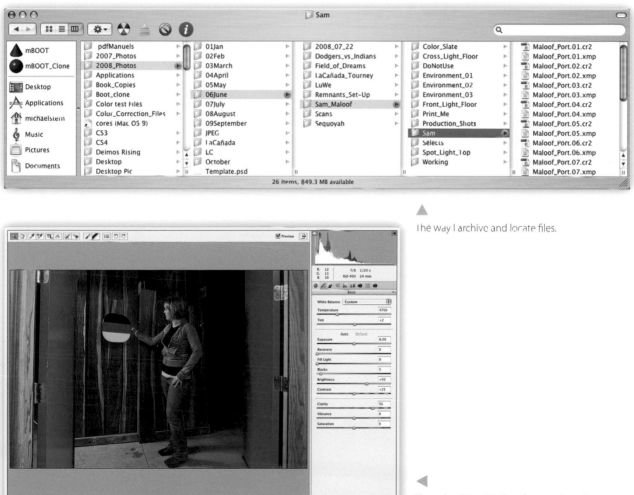

The way I archive and locate files.

The color slate with the aforementioned Jacalyn.

all the people involved, pack up and head back to my office, where the next step begins.

Photoshop Prep

Metadata is input as the files are transferred to the computer. All files are put into a single folder and this master folder is backed up onto a separate hard drive. I use Bridge to categorize the captures into folders using descriptive names.

In the "Color Slate" folder is a capture with the color-balancing target in the main scene, lit by the ambient light and the speedlight. I dial in the color, contrast, density, sharpening, etc., using this reference frame. I click on each value of the target because subtle shifts occur for each value and I want to evaluate all options.

I rank the captures in Bridge and copy the selects into the "Selects" folder. The selects are processed using adjustments made with the "Color Slate" capture. I process the files into 16-bit, ProPhoto, Smart Object files. I drag and drop the files onto the file designated as

the "Base Image" of the composite. I use **Layer Masks** and **Blend Modes** to see how close I am to my pre-visualized end result. At this point, I may have 20 layers in the file, over a gigabyte in size. You might be thinking at this point, "Why not make jpegs and do this step in a much smaller and quicker layered file and then go back and do it again with the big files?" In the past, I have made small jpegs and worked out my ideas, then gone back and done everything over again with the big files. I found this to be OK for a commercial project with specific client parameters, but not OK for my personal or portfolio work. When I work with small jpegs and get into my creative zone, I am one with the file. It is difficult to repeat this state of mind a second time around. It's no longer fresh. Creativity is not linear and, by definition, postproduction takes many hours. The path zigs, zags, stalls, dead-ends, and often repeats itself many times before success is attained. I am not interested in working quickly; I am interested in results. I respond

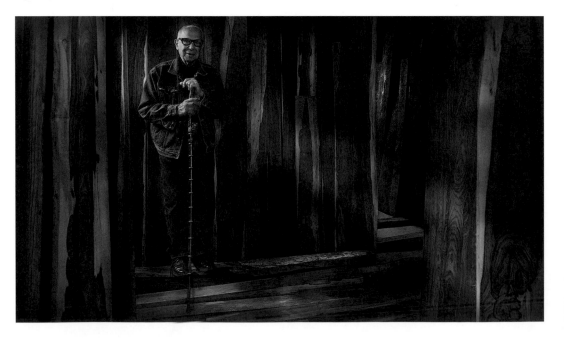

The finished portrait of Sam. He was very pleased with the framed print I gave to him as a thank you. He hung it in a place of honor in his home.

emotionally to the portrait files after working with them the first few minutes. It is pure, new, and mostly right-brain. I am not programmed to repeat these steps with files a hundred times larger. Earlier I said that large files slow down the process and give me time to contemplate what I'm trying to accomplish. They act as a built-in governor, if you will. And I make it work. Art thrives on limitations. Take it for what it's worth. I use a big, powerful computer, and while it churns data I can think about what I'm trying to accomplish. Sometimes I mind

waiting, but getting the results is always worth it.

I'll use a woodworking metaphor here. In many ways the portrait session is like rough-cutting wood. I make all the pieces ready for assembly. I fit the pieces together in Photoshop, using ACR to cut my files into the final sizes, shapes, and colors. While in Photoshop, I use 50-, 80-, 100-, and then 400-grit sandpaper (adjustment layers, clone, heal, filters, etc.) to burnish my idea and smooth the finish before going to print.

▲ ❶
No Shadows.

▲ ❷
Adding contact shadows underneath shoes and cane.

▲ ❸
Adding cast shadows underneath shoes.

▲ ❹
Adding cast shadow for cane.

▲ ❺
Smudging cane shadow to conform to the steps.

▲ ❻
Composite without shadow effects layered in.

▲ ❼
Composite with shadow effects layered in.

This is the story I saw and wanted to tell. I felt this image from the beginning, but it was a time-consuming to get to this spot.

Contact and Cast Shadows

The application of contact and cast shadows is important to this discussion about realistic compositing. After Sam's image was placed into the file, I created two shadows: one cast and one contact. These shadows provide weight and anchor Sam to the scene. Without them, it looks like he is on a pogo stick. Not bad for a 92-year-old, but not realistic, either.

I added cast shadows to the shoelaces, shoes, and cane. The direction was dictated by the direction of the main light coming from camera-left. The contact shadow was put on the bottom of the cane and underneath Sam's shoes. Each shadow was done with multiple layers to slowly build up and control the effect. Painting isn't my best thing. I am very aware of my limitations and have developed coping methods over the years. My goal is realism and a truthful expression of my feelings about a subject.

The cane's cast shadow was bent using the **Smudge Tool**. This made it conform to the contours of the wood. One more way to add a bit of realism.

I present the **Layers Palette** in two parts. I rename "Adjustment Layers", which makes it easy to select the right one to edit when glancing at the palette. This minimizes guesswork and saves time. Take note of the following screen grab where the **Layers** are named "Maloof_Port_31", etc. These are the names of the files used to make the background composite, arguably the critical component of this environmental portrait. If any of these **Layers** became corrupted or damaged beyond repair, it is an easy task to retrieve the RAW file from the "Selects" folder and reprocess a new file.

Summary

How do I describe the feelings created by the many hours of futzing back and forth, making way too many test prints to evaluate the story? Or my feelings of dismay when clearly it isn't working, giving up and being resigned to failure? Then suddenly, like a bolt of electricity flowing through me, adrenaline and instinct take over. The work is finished and is as successful as I originally imagined.

In this chapter we've talked about my creative process. I call it the image hit. You no doubt have your own name for this phenomenon. We've looked at some of my background and dissected several examples of my work. I've walked through the process, from idea to execution to completion. While I've played down the technical portion of my imagery, it is no less important. But this book is about deconstructing and demystifying the process and procedures of creativity.

Make the commitment to create. Be well trained in the tech aspects of your craft. Constantly upgrade your skills. Be passionate and do what you feel is right while carefully weighing the influence of others.

Good luck.

▶
The Raven

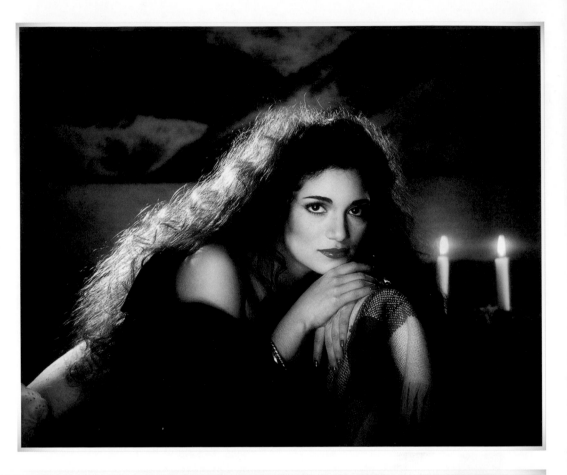

▼
No Impact Man, Colin
Beavan

◀
Olga

◀
Sunset Girl

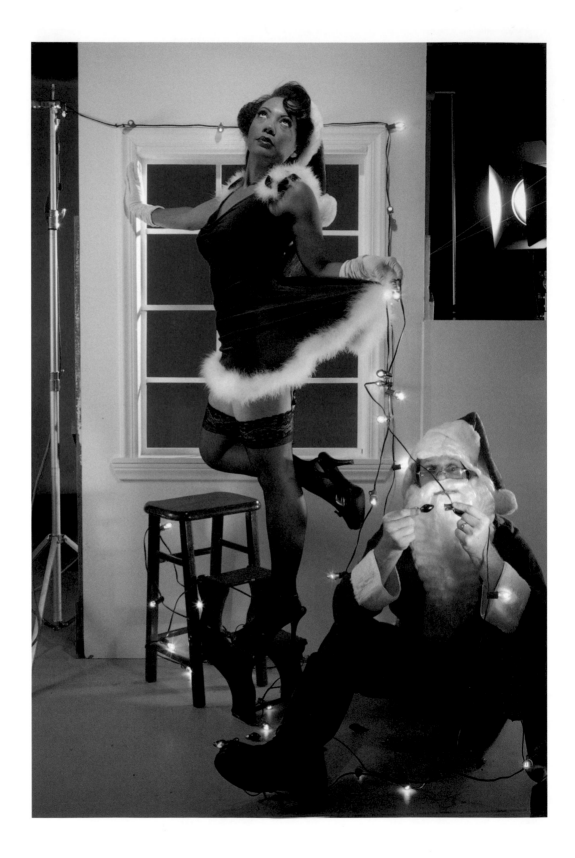

CHAPTER 2
Compositing Techniques

Santa Girl

By definition, professional artists are compelled to find new ways to express familiar ideas. This is easier said than done. Add into this mix the skill set necessary to maintain a thriving business and you have a recipe for stress. And more. Ah, but it's good to be an artist.

This chapter's topic is a photo session from November, 2006. It is a multi-image composite shot taken at my studio for my friends Rachel and Eric, who every year around the holidays become Santa Girl and her helper Santa. We have been photographing these vignettes for many years, so originating a topical concept every year is important. If you feel so inclined, the DVD contains several movie clips from a documentary filmed during the shoot. This material contains behind-the-scenes dialog about how we broke down the issues, came up with creative solutions, and had fun in the process. Other Santa Girl composites are at the end of this chapter.

Let's get to it.

In my workflow, compositing and collaboration go together. I am the lead dog and ultimately responsible for the end result, but it's great to have observations from others on my assembled team. They are handpicked for this reason.

Collaboration, for me, is having another set of eyes looking at the work as it progresses. These observers make solicited and (gulp!) unsolicited comments. All comments are listened to and some are acted upon. I do have pride of ownership, but others are encouraged to contribute, as it adds to the sense of community I create when working on a composite. Depending on what's at stake, people on my team are picked for their personalities, attitudes, and specialties. I surround myself with good vibes so the process is as pleasant as it is intense. I am demanding of myself and others, but it's also a lot of laughs. Composite photography sessions can easily take eight hours and more to shoot. Add postproduction Photoshop hours and you're in for a long ride. Bring a few snacks and a pillow.

Rachel and Eric were doing Santa Girl before I came along. Rachel and I have known each other for over 20 years. I'm in her office one day in early 2002 looking at a very bosomy photo of her in a revealing elf outfit. It was sexy, but poorly lit and boring. After talking about what this photo was for (a holiday promotional piece for her photography business, as it turned out), I offered to work with her on the next one. I love volunteering to do something outside of my comfort zone. Living on the edge with my personal photography drives me to accomplish what I desire to accomplish

professionally. That's me. If I've never done it before and it's something I've wanted to do, and there's an opportunity in front of me, then I go for it. This is a great way to grow. I get tremendous experience in all aspects of the creative process: conceptualizing the idea, preproduction and budgeting, the actual shoot with its attendant issues, and postproduction. It's better to work out the processes with nothing more at stake than pride so when the phone rings with a paying gig, you're ready with the knowledge of what it takes to deliver, what it costs, and what should be billed out to the client. Creative commercial photography is a business and should be treated as such.

As a professional photographer, I hold myself to a very high standard. Even if my client is on a beer budget, I deliver champagne results. Once I accept an assignment, my client and his or her project get my complete and undivided attention. Period. I do this for reasons of professional pride (I must know I deliver premium results); I do it to protect my pricing structure (part of my sales pitch is that I deliver guaranteed results or the assignment is no charge); and, finally, I hate looking at poorly executed work. Both technically and creatively, I want to do it better than other photographers. When I see a poorly executed assignment I would have been perfect for, I go nuts. I want that opportunity the next time! I work very hard to get those next opportunities. It's a great profession. Respect it and always do your best.

Pimp My Sleigh!

This incarnation of Santa Girl began with a meeting on October 11, 2006. Rachel/Santa Girl and Eric/Santa Claus met me at my studio. They usually have an idea of what Santa Girl will be doing in a given year. This time it was "Pimp My Sleigh!" During the meeting we looked at and were inspired by the pin-up paintings of Gil Elvgren, World War II airplane nose art, and reality TV. My first job was to help them flesh out their ideas, from a story-telling, photographic, practical, and technical point of view. Then I gave my interpretation of what Rachel and Eric wished to do for the photograph.

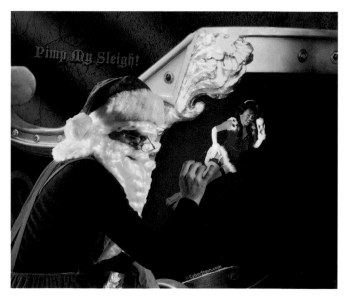

We agreed on the concept, visual approach, and set/props. As we worked further on the idea, logistical and creative problems emerged.

The Firing Line

A concept must first be vetted. This is a revealing and sometimes frustrating process,

but it's necessary to maximize the time and energy we spend on the story. The process of vetting all the elements must be systematic. This goes to the heart of a good creative workflow. So I ask, "Does the idea have merit?" "Will the audience get it?" "Does that matter?" (Hope so.) I ask myself if it can be accomplished photographically. What has to happen before the shoot? What are the practical considerations (props, costumes, makeup, hair, accessories, assistants, food, music, etc.)? What are the technical considerations (focal length, point of view, camera format, depth of field, lighting quality, lighting modifiers, gels, special effects, tripods, set design and construction, etc.)? What must be created at the moment of exposure and what can be left for Photoshop? Are scale models or other specialty objects required?

These were the issues discussed during the two-hour meeting. As is always the protocol for us, we divided up duties so each of us had something to contribute to the process. Eric is an experienced CAD person, so he suggested a CAD image for the sleigh. During the meeting, he made some sketches of how he proposed to make a full-scale model of the sleigh. I realized right then that whatever he created would probably require much effort in Photoshop to achieve the quality result necessary for this concept to work. I began thinking: Was he testing me or did he just like to sketch?

I suggested that a quality scale model, photographed by yours truly, would be much better and, although it would require Photoshop magic, it couldn't possibly demand more than Eric's idea of building one through CAD. Whew! Problem solved. Unless of course we couldn't find an acceptable model sleigh prop. Not being able to find an acceptable prop in LA? The entertainment capital of the world?

No problem. We set about identifying a number of stores that would be logical places to begin the hunt for the model sleigh. The game was afoot! But we were tripped up by the unexpected.

So now we have our concept worked out. Santa dressed in red long johns and suspenders, painting "nose art" on the back of his sleigh. His subject? Why Santa Girl of course, looking fabulous with her long legs, short skirt, and beautiful, full, luscious hips. Thank you **Liquify Filter**.

The composite will be a point-of-view looking over Santa's shoulder as he works on the details of his sleigh art—the alluring curves and sensuous demeanor of Santa Girl. We see enough of his environment to get the idea of where he is working and what he is working on. There may or may not be other identifiable items in the scene, such as tools, a cart, paint, rags, and a sketchbook.

The back of the card will feature the full setup from which the nose art on the front cover is taken. Set in the style of a 1900s artist's studio, suggested by a small platform covered in a sheepskin, we see the lovely Santa Girl posing in a variety of ways. Although it didn't work out this way, that was our original idea. We were just as happy with the end result. The final photo is on the DVD under the "Santa Girl" movies section and at the end of this chapter.

Santa Girl Production Notes

When I work on a piece, I'm often focused on the technical aspects: perspective, lighting, focus planes, blended edges, color, contrast ratios, etc. It's easy to miss little things—like a composited character looking pasted-on as opposed to blended-in.

For example, the difference between these two images is the cast shadow coming from Santa onto his sleigh. Until this was pointed out, I missed one of the crucial rules of compositing: have two shadows when compositing an object or a character into a composition. The first shadow is a cast shadow following the direction and hardness of the key (main) light source. The second shadow is the contact shadow if the subject/object is touching something. This process connects the element to the environment. Without it, the image tends to look flat and pasted-on.

▼

Without cast shadow

Shadows provide weight and give strength to a story, and compositing is a form of storytelling. I composite images together to help tell a story. A lesson to be remembered.

Think about the appearance of the transition edges of the objects in your composite. Always ask: If this story had occurred in real life, would the edges look like those in your photograph? Would the shadows? If the answer is no, then rework until you can answer yes. This can be extremely difficult, but never give up. Giving up is easy. Working it until it's correct is stressful, time-consuming, and the professional way to proceed. The desire to achieve your creative

▲

With cast shadow

goals (putting in the time necessary to succeed) is what separates pros from wannabees.

Professionals spend a lot of time working on refining their technical workflow. This includes camera settings, file storage, RAW processing, and printing. A creative workflow is important, too, but rarely talked about. The process of vetting the elements of a composite must be as systematic as a traditional workflow. A creative workflow begins with deciding what story is being told. Is it action? Comedy? Drama? Tragedy? Political? Who are the players in the story? What elements are required besides the talent? Are the elements categorized? Are they all in the same place, easy to access? How much time do you have? How much time have you been given? Are you following a layout? Tracking changes helps keep one on task. This goes to the heart of a good creative workflow: the back-and-forth rhythm of moving this edge, blending that value, adjusting this mask, transforming that shadow, or cloning out a distracting element. Tracking your workflow will serve as a reference for future editing sessions on the current composite, and will do double duty as a guide for refining the next composite project. I do this several ways: the **History Log**, a screen-grab of the **History Palette**, audio recordings, the **Note Tool**, and, of course, good old pen and paper. At this point in my career I don't use all of these all the time, but I do use them in combination, especially when it's a particularly difficult composite with lots of nuances, components, and substance. Using the **Note Tool** and screen-grabs is usually enough now, as so much of my creative workflow has become second nature.

Pieces of the Puzzle

This section will take you through the thinking that drove the photography decisions, the edit

decisions, and the Photoshop decisions in this project.

The very first order of business was to solve the sleigh problem. Plan A was Rachel going around to stores taking snapshots of sleigh products, lamps, flower pots, book ends; you name it and they make a sleigh motif out of it. Purchasing a scale model was a good idea in theory, but it was difficult to locate an acceptable model with enough fine details to hold

▲ Egads! A no-good CAD

up when enlarged to human scale. This was the unexpected problem I alluded to earlier. Plan B was having Eric make a series of CAD illustrations of sleighs in different perspectives. A CAD image was going to require a lot more Photoshop work than I wanted to put in, so this idea was scrapped. Plan C was making a blank cardboard cutout (scaled to life-size) in the shape of a sleigh and, once the principle photography was complete, coloring and texturing it using Photoshop. We lacked the talent, time, and budget to do this convincingly, so Plan C didn't make it either. Only 23 letters to go. No matter how hard we try to produce these vignettes without being rushed, it seems like we always run behind. Composite photographs take a boatload of time and

energy. And each year we just can't seem to get an early enough start. Rachel promises we'll get an early start next time. Where have I heard that before? Oh yeah, in 2003, 2004, 2005, 2006

We decided to rent a full-scale sleigh for the shoot. Rachel went to a number of Hollywood studio warehouses and took snapshots of several sleighs in the perspectives we needed. We all agreed on one, but after we were quoted a rental fee of one thousand dollars per week, we went to Plan D. Mind you, the thousand bucks didn't include prepping the sleigh or transporting it to and from its warehouse location; nor did it include insurance.

You may be asking yourself, "If this guy is a digital convert and a Photoshop expert, why even consider a full-scale sleigh, why not just import a good photo?" Fair enough. I answer the question like this: I am a classically-trained, film-based uber control-freak photographer. I prepare as much as possible so it all comes together and happens at the moment of exposure. I want it as real as possible when I'm shooting. What can I tell you? Twisting and

▼

Too plain-Jane for my vision. Looked at it anyway for comparison.

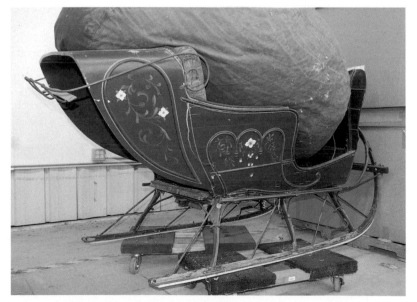

turning as they spiral into the ground, some photography habits die hard.

But I am flexible. Creative people bend so they don't break. We must do as much as we can to be true to ourselves in achieving our goals despite the issues that come up. It ain't easy sometimes. And it's all too tempting to become blinded by a chosen and difficult creative strategy that you've convinced yourself will work, while other solutions in front of you languish. In this case, the path we finally took could have been taken much sooner had I been more flexible earlier in the process.

I wanted to work with a full-scale model. It sounded so cool. It would have made for a terrific spectacle in my studio. Picture it. I did.

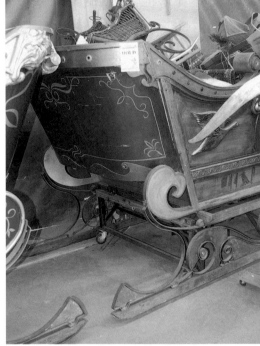

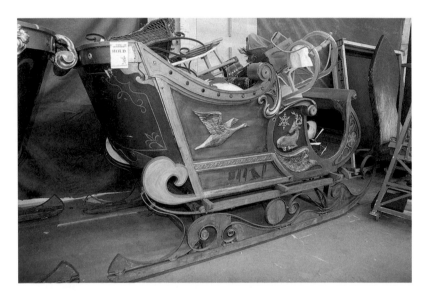

▲
Nice detail, but a thousand bucks! For three days.

Oh well. Did I mention the thousand bucks? Next: On to Plan D.

What was Plan D? Perform a bit of Photoshop cosmetic surgery on one of the snapshots Rachel took. It is Hollywood, after all; we're used to cosmetic surgery. The image to the left was perfect. And, fortunately, the on-camera

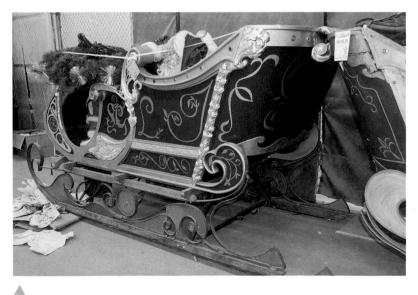

▲
This one had the "look", and Rachel shot it with the correct POV..

frontal flash gave the sleigh an evenly lit front plane conducive to the lighting effects I wanted and needed to create.

I've said it in the environmental portrait chapter and I'll say it here: art thrives on limitations. I tell my students we are creative solvem problers. Don't let anything get in your way. Work around the difficulty—there is a solution if you look hard enough and want it bad enough.

It was important to finalize the sleigh issue before proceeding to the photo sessions of Santa Girl and Santa. I say this because I wanted to quickly composite all three elements to double-check perspectives, lighting, depth of field, and size relationships. This relieved some of the doubt that accompanies all creative work.

The element at the right-side rear (in the image below) is a duplicate of the left-side rear element, moved, toned down, and shadowed. On the original photograph, this section is gray without detail or texture. I need to do whatever I can to make a visually stunning image, and this step moved me closer to that goal.

The combined pieces are beginning to work well together, but something is still not right. I can smell it and taste it but can't yet identify it clearly enough to design and apply the fix.

Usually, when any one part looks a bit out of sync, it can destroy the believability factor of the entire concept. Beautiful, but no good. I hate when that happens. Doing the right thing can also be a very difficult thing to do. Let's move on; we're burning daylight.

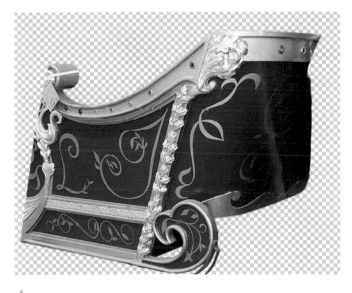

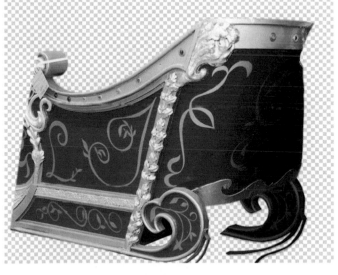

The sleigh after a bit of **Layer Mask** magic and a slight change in perspective via **Edit > Transform > Skew**.

On the next page are details of the cloned and toned elements.

▲ ①

Original.

◄ ④

Buttons are cloned along the top front edge and lightened. The far right edge is cleaned up and extended. Bright gold highlights are toned down. The gold line is cloned out for Santa Girl to have a clean background to reside upon.

▲ ②

Cloned element.

▲ ⑤

The wall of Santa's workshop is a faux slate floor leaned against a wall and lit as if there were a wall with an off-stage light from the viewer's left.

▲ ⑥

Adding a striped gradient with the **Gradient Tool** marked the beginning of a believable lighting effect that supported the overall idea of this storytelling composite.

▲ ③

Shadow applied.

◄ ⑦

Added a bit of tone and density with a **Hue-and-Saturation Adjustment Layer** and I'm almost finished.

▶ **8**

I began mulling over the compositional idea of contrasts, big and little, light and dark, warm and cool, hard light and soft light, etc. It then hit me: I had to make the sleigh appear as though it was being lit by a soft-edge (diffused) spotlight.

▶ **9**

At left is the effect of applying the **Lighting-Effects Filter** on a duplicate layer. I think it's a beautiful solution. I loved it then and still do. But it is too dramatic. It calls too much attention to itself and proved to be distracting to the overall story. When compositing, the individual parts should support the whole idea.

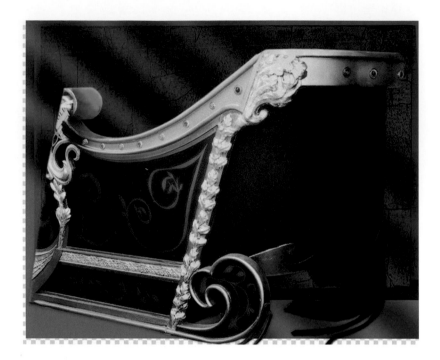

Pictured above is the final look of the sleigh. At this point the sleigh and background are separate elements. Colors were edited (changed) separately using **Hue-and-Saturation Adjustment Layers** with the "Colorize" box checked. The glow on the sleigh was rendered by the **Lighting-Effects Filter** set to Spotlight, but this time I added more ambient light to lessen the effect of the spotlight. If I had been lighting a full-scale sleigh, the equivalent would have been to use to use a spotlight with a lot of fill-light around the edges to cut (or lower) the contrast. Again, being a traditionally trained photographer with a lot of lighting experience provided me with the background I needed to use Photoshop's tools to create a look that I would usually create in-studio. I adjusted the size of the spot and moved the Properties sliders to dial in the look I felt was appropriate. After making a loose soft-edged selection around the area where Santa Girl would be placed on the sleigh, I

toned down the blue color cast by using a **Hue-and-Saturation Adjustment Layer**. The spillover of blue light on the sleigh was deliberate. To enhance the overall effect, Santa was lit using a blue gel. This helped anchor him to the background elements.

In the final composite, the glowing area set for Santa Girl was lightened for reproduction purposes. After all components were brought together into Photoshop, the warm colors of the sleigh were additionally saturated so the elements worked better together. I am a fastidious futzer when it comes to this work—there's always one more thing to do to a file. Artists must always keep the end in sight at the beginning. In this case, it was reproduction on a printing press. Commercial work usually ends up on press and decisions are made aesthetically and technically to achieve agreed-upon goals. This is one of the many roles artists take on during the course of their careers.

There are a lot of spiffy controls for the **Lighting-Effects Filter**. These controls are only as good as the user's knowledge of light direction, specularity, diffusion, color, contrast, and brightness. Without this understanding, the controls have to be played with a bit. Be sure to click OK to see the results rendered in your image, as the preview is not as accurate as it should be. Also, be sure to work on a duplicate layer so **Blend Modes** and **Layer-Opacity** adjustments can be made to further refine results. This approach is best if you have a lot of time or lack a discerning eye. I have more of the former than the latter. There are, of course, many ways to achieve a particular effect in Photoshop. If this dialog box intimidates you, keep at it until you get something that works. Or try something else, but don't give up on your desired effect.

For example, a selection around the area in question could have been made first. Afterward, a **Hue-and-Saturation Adjustment Layer** could have been invoked to change **Hue** and **Lightness**. Blur the adjustment-layer mask using the **Gaussian Blur Filter**. Remember that blur settings can be higher with hi-res files. If I had chosen this method, I would have used a 50-pixel radius based on a file resolution of 360.

Making the decision to go with the **Lighting-Effects Filter** greatly simplified the shooting, as I now had less work to do on the sleigh. We also didn't have to shell out a thousand dollars plus, and the savings were redirected into postproduction work.

Understanding color as hue, saturation, and lightness (or brightness) takes effort but lessens the guesswork involved in matching color values. Learn how to measure color in Photoshop with the color picker (set to 3x3 or 5x5) and the **Info Palette** to understand how to identify and measure the color values at a

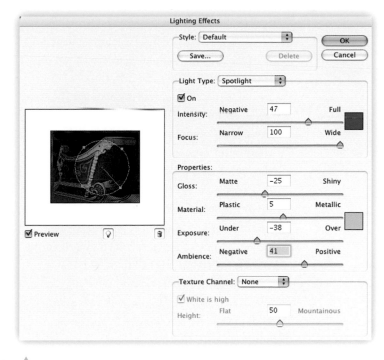

The Lighting-Effects Filter dialog box

The light above Santa's head was positioned to throw an edge of light along his left side, matching the direction of light on the sleigh. I then chose a blue gel closely matched to the blue color selected in the Lighting-Effects Filter dialog box.

specific location in an image. It is important to know color and to have a color-managed workflow to ensure predictable and controllable results. Understand how the CIE color model (CIE LAB), created decades ago, became the basis for today's color-managed workflow. Read the "Color Management" section of this chapter for more information about CIE and the ICC as they relate to color management.

Looking back at the previous photo of Eric in his Santa suit, you'll notice his hand is holding a paintbrush near a white dot. This white dot served as a placeholder for the photo of Santa Girl on the sleigh. We had to have a reference point for the correct positioning of his hands. We shot a variety of poses: with one hand, with both hands, holding the paintbrush, holding a cup, and with just Eric's hands sizing up the art. The yellow seamless paper served to contrast with the colors of Santa, making it very easy to select him out of the background. With such obvious contrast, even the **Magic Wand** works wonders.

Color contrasts are a key component when producing composited imagery. In the movies it is called chroma keying the background. The ideas are similar. Pick a color that contrasts with the subject's color and after shooting, with the push of a few buttons, the subject is outlined and ready to be inserted into the composite. Green is used for this technique, but any color will work as long as there is sufficient contrast. Many tools in Photoshop are designed to look at contrast in a variety of ways. Make life easy for yourself. There is plenty more hard stuff on the way.

▲

In a lot of ways it's the little touches adding up that really finish off an idea and greatly contribute to the overall believability of the story. Here, my daughter Lauren is finishing up Santa Girl's make up. She is an accomplished makeup artist and I treasure working with her.

▶

Here Santa Girl is getting ready to give me her opinion. I can hardly wait.

The shots of Eric have been completed, a key frame chosen, quickly outlined, and dropped in with the background elements. Then, after making a few test captures of Santa Girl, I quickly masked her from the background and dropped her into the composite. This is why I wanted the sleigh file ready beforehand. Another example of having the end goal in mind when making necessary creative and technical decisions. You'll notice that, at this point, the slate background of the image is still warm—not the cool color I eventually decided to go with. I believe that artists are compelled to examine all legitimate possibilities regarding their ideas. This begs the question: If Santa was lit with a blue gel, why are you even looking at it with a warm background? I look for color contrasts and color harmonies in my stories. I had to be satisfied that cool was better than warm. This process takes thought, time, energy, and knowledge. I've said this before but in a different way: take your time to think, feel, and believe in your view of the world. Touchy-feely again, but we are emotional creatures, so we must embrace this process.

Here Lauren and Pat are making adjustments to makeup and the pedestal Santa Girl is resting upon. I am just over Lauren's shoulder waiting for them to conclude their business. I'm showing my exhaustion because I've been working on this composite for nine hours already, with three hours still to go. Check out the bags under my eyes on the DVD. In fact that's an entire set of luggage. The work is draining.

The sleigh was too long for the format of the printed piece, so I edited the perspective. This was accomplished by cutting off the front of the sleigh and moving it right.

The finished sleigh composite. The overlap was covered up by Santa.

The raised pinky finger is my salute to Emily Post and The Three Stooges.

The back of the painted hand..

See the cool color on his back and the warm color on his beard? This is an example of color harmonies I look to introduce into an image.

▲ Love that figure!

Breakdown

Here are screen grabs of the main components for Santa Girl, vintage 2006.

Did you notice the paint on the back of Santa's hands? Remember me stating that the little things add up? Even though the impact of the paint-stained hands was minimal in the final piece, thinking about how Santa would have looked if he had actually spent time painting the sleigh (and getting paint on himself) made me think about the little details needed to bring this composite up to the level necessary for the realism we were trying to achieve. I also took this idea and put digital paint on the brush tip itself. Very few details should be ignored when creating reality from scratch.

The nose-art component breaks down as follows:

▢ The red glow around her body was added to blend in the edges of her figure with those of the sleigh. This is similar to feathering selection edges to facilitate smooth transitions. Think back to the discussion about the **Lighting-Effects Filter** dialog box.

These "wires" were hand-drawn using the **Pencil Tool** set to around five pixels; the title of the composite was positioned and cantered to appear as though it were hanging by these "wires".

The text layer was duplicated along with the Layer Styles. The upper layer was set to an opacity of 50% and the layer beneath was set to 35%. Can't explain why it was done this way; it just gave me the correct look.

- The faded-out feet indicate the painting is incomplete. Santa's work is in process and hopefully he will complete the task before he takes flight. I also looked at fading the lower part of her body with black, but I decided that lighter values and partial transparency served the story better.

- The shadow edge of her figure has also been subtly toned down. This reinforces the direction of light and helps create a dimensional effect in the finished composite. Good photographers recognize the direction and quality of light and make decisions in line with the qualities of light present.

- One of the video clips on the DVD is a close-up of Rachel in the makeup chair, with what appears to be way overdone Santa Girl makeup. I agree that it looks overdone, but it was done this way on purpose. The final image of Santa Girl is reproduced very

small. The makeup had to be very big and very loud to look right at this small size. Get it? This is not an uncommon practice. Lauren, Rachel, and I were on the same page, so all went as planned.

The last two components were photographed but not used. I shot the tool cart because I wanted to acknowledge the garage/workshop atmosphere we established in preproduction. This shot also followed the *Pimp My Ride*

aspect we were emulating. I shot the wall sconce because I wanted to add a touch of whimsy to the story. Wrong. Wrong. And wrong again. Oh well, the creative process throws up a stinker every now and then. But you gotta run it up the flagpole and see what happens anyway. Nothing ventured, nothing gained. These two elements weren't necessary to contribute to the story as imagined. It was an easy decision to eliminate them, plus less work. We all win.

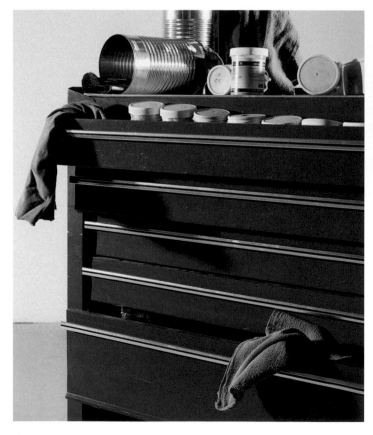

▲ Red cart.

▲ Wall sconce.

Layers, Channels, and Paths— Oh My!

Everything I need to edit this file in the future is contained within the following **Channels**, **Paths** and **Layers** palettes. I referred to this idea in a previous chapter as the Flexible File Format, or the 3F File. This is not a new idea; I just gave it a name that made sense for me. I will be able to do whatever I need or want to do with this file in the future. Future desktop printers and monitors will be able to print and display larger gamuts like the ProPhoto color space and 16-bit files will be as common as 8-bit files are today. When this day arrives (and if I'm still able and interested), I can go back to the RAW files and reprocess them using all of the new technological breakthroughs. Given that my files are saved in the 16-bit ProPhoto format, I will be able to go anywhere with my files and achieve predictable and accurate results. Professionals deliver repeatable and predictable results. We can be control freaks and digital imaging provides controls and tools at new and more sophisticated levels. Obsessive-compulsive behavior has met its match. If you're extremely particular, digital photography can fulfill your fantasies.

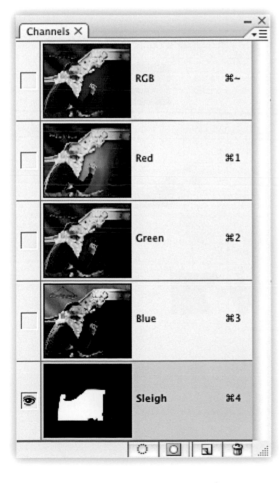

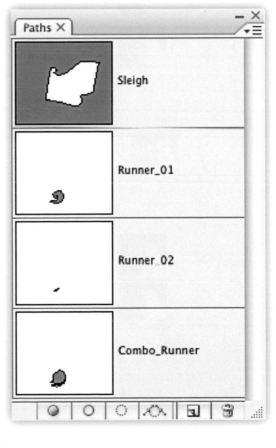

The complete Layers Palette.

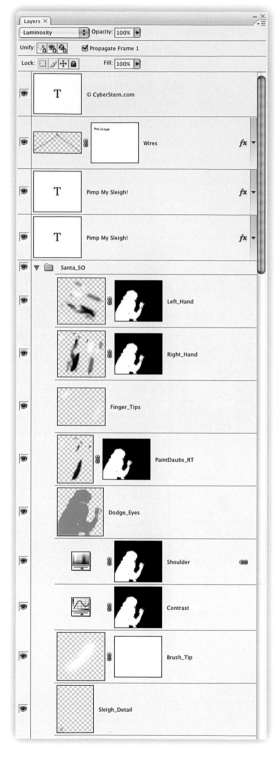

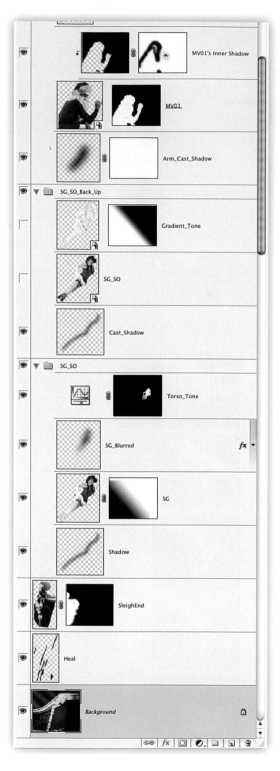

Since I do so a lot of layer masking, I have converted some channels to paths to save space. Either way, it's all there in the 3F File.

In staying with the idea of the 3F format, this folder contains the original **Smart Object** of Santa Girl. File quality is not compromised when upsampling and downsampling multiple times with Smart Object technology. Working to achieve an acceptable size and range of tonal and color values to blend with the sleigh,

I upsampled and downsampled the file several times. In the end I converted (rasterized) a copy of the Smart Object to a regular layer for ease of use once I got the correct size. Remember, though, I still have the Smart Object in the file as a backup. The 3F is working perfectly.

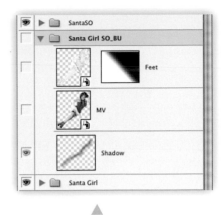

SO is short for Smart Object.

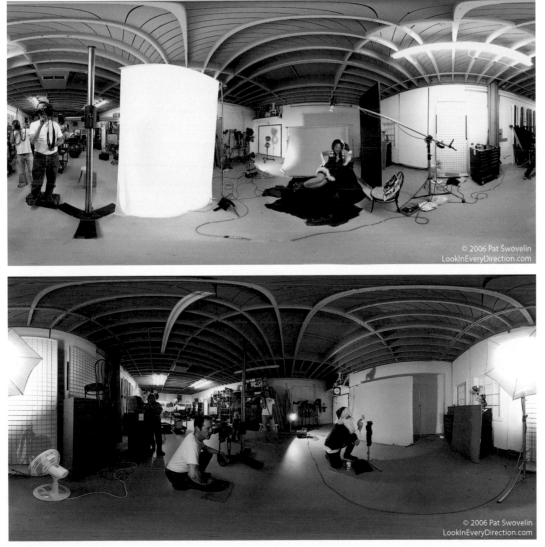

Pat's panoramas from Santa Girl, 2006.

Color Management

I mentioned earlier the importance of learning how to edit color using Photoshop. The following information is meant to motivate you to explore on your own how color management produces predictable, high-quality results. In the simplest of terms it is known as "WYSIWYG" (what you see is what you get).

As files move through a color managed workflow, adjustments are necessary to maintain accurate and predictable color throughout. Color management uses the LAB color model and a profile connection space (PCS), to determine how specific colors (represented by red, green, and blue numbers) used by a particular camera, monitor, scanner or printer are adjusted from input to output.

The CIE, short for Comission Internationale de l'Eclairage (International Commission on Illumination), was founded in 1913 to provide a forum for the exchange of ideas and information and to set standards for how the human eye perceives color. From this commission came the three-dimensional L a b model (*L* stands for lightness, *a* for red-green, and *b* for blue-yellow) for describing how humans perceive color; it is the foundation for color management systems. The professional artist today can control and predict input and output color results.

Input (cameras and scanners) and output (printers) devices use unique sets of numerical data (numbers) to control how they produce or represent color. A color management system converts (manages) these numbers as the file is moved from one unique device to another unique device or, for example, from a Photoshop file to any type of print-making device. Color management understands the way each device receives color data and represents color data, enabling us to perceive the same color as a file moves through any computer system,

camera, scanner, or printer. The color management system uses color profiles and working color spaces to identify and manage these unique color characteristics. A PCS (profile connection space) is the other component integral to the task of converting between input choices and output choices. The PCS is where color data is examined, converted, and sent on its way.

Go to www.color.org to learn about the International Color Consortium (ICC) and its work beginning in 1993 to promote an open color management system that is vendor-neutral and cross-platform capable. Prior to the ICC, there was no way to translate color numbers from one unique device to another. The work of the ICC allows artists to choose printers and computers to suit their needs without having to worry about obtaining accurate and predictable results between devices in their workflow.

Prior to the ICC, if you wanted an inkjet print matching what appeared on your monitor, you had to use a printer made by the same manufacturer that produced your computer because the language of color production was unique to specific manufacturers and worked only within a manufacturer's closed-loop system. In years past, there wasn't a way for a printer made by one manufacture to understand how color was handled in a computer made by another. This was limiting and locked you into to a specific manufacturer. We did a lot of complaining. Adobe felt our pain and beginning with Photoshop v5 rocked our world with a color management system built into the application. It began with the introduction of working color spaces. Professionals and manufacturers are grateful for their contributions and support of our art. Visit www.colorsync.com for more information about this topic.

Summary

Composites begin life as ideas. Not always good ideas, but ideas nonetheless. After mindful reckoning, they become good ideas. These good ideas can then be translated into good composites. Ask these questions: What story is going to be told? What methods can be used to tell the story? How can the tasks at hand be accomplished?

It's important to learn many of the tools in Photoshop and how they work in a variety of situations. Photoshop is a numbers game. Image files are composed of numbers. Photoshop adds, subtracts, multiplies, or divides these numbers to effect change. When one fully appreciates this aspect, it becomes easier to select the appropriate tool when rendering visual effects. or retouching, or color editing, or profiling. It makes experimenting less hit-or-miss, more educated, and useful. It's good to be smart.

Creative professionals also need to explore what it is that makes them tick. I know what atmosphere I need when I'm doing large-scale productions and surround myself with hand-picked assistants, makeup artists, hair specialists, interns, food, music, and invited guests. Watch the footage on the DVD that was shot during the Santa Girl shoot in November 2006. During a shoot, I'm playful and serious, demanding but flexible. I play off these special folks and they in turn contribute to the atmosphere I have deliberately created for specific shoots. There is camaraderie, creativity, friendship, growth, understanding of self, education, playtime, music, food, goofing off, and hard work. It's an atmosphere conducive to true collaboration while working toward a common goal.

Some of the benefits from this created atmosphere come in the form of contributions and feedback from less-experienced participants. Much of it is unusable, but occasionally a real gem pops out. I ask people who are unfamiliar with the process to participate and hope they become empowered enough to offer an opinion. These are fresh eyes, new to the process. Some may see this as taking advantage of my position, but I look at it like this: I invite them to have a new experience, and enjoy refreshments (and often entire meals); they learn something about the creative process. My goal is to come back with successful results. This is a classic example of risk vs. reward. I'll take the setup, the cost, and the risk to get my picture.

Have fun. You know I did.

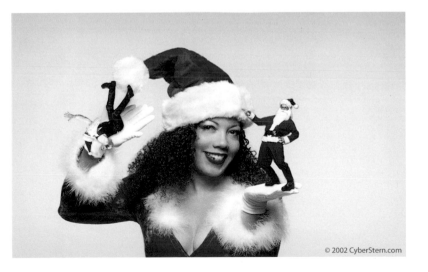

Good Santa and Bad Santa, 2002

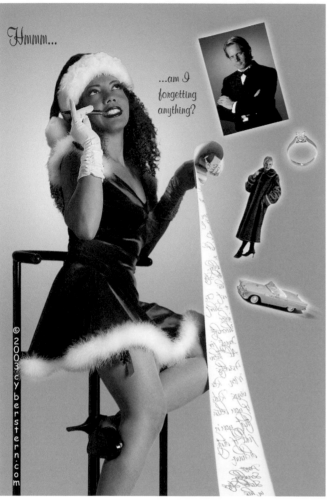

Making My List, 2003

Getting Ready, 2004

Traveling in Style, 2005
front

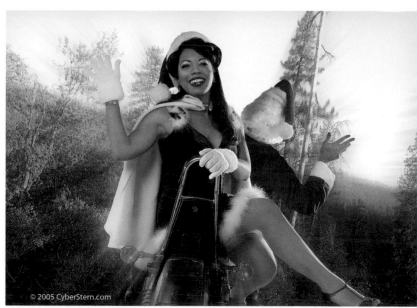

Traveling in Style, 2005
back

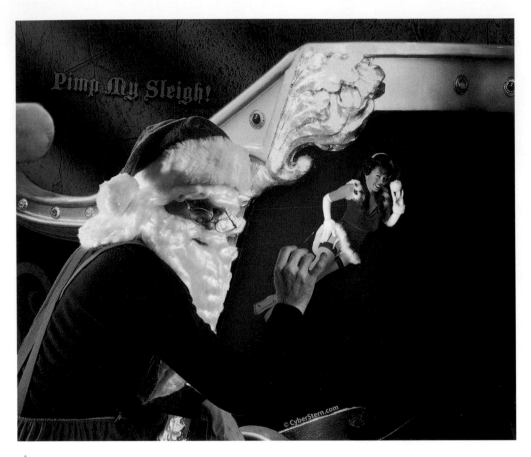

▲
Pimp My Sleigh, 2006 front

▲
Pimp My Sleigh, 2006 back

Santa Girl, 2008

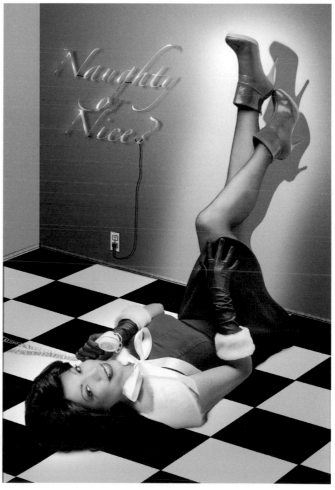

Santa, 2008

CHAPTER 3
3D Scanning of Found Objects

Remnants

I t is my belief that all creative beings need an outlet for creative thinking. But how many of us search this out on a regular basis? How many of us have created a body of work that reflects this belief? It takes passion, determination, and a commitment to pursuing your creative goals. Over time, the body of work builds up and the persistent viewings by others and a review by the creator (you) provides a stimulus that begets additional inspiration and the drive to create more work. This chapter discusses how I apply this belief system and how I use it to create work.

This discussion begins with the story about the image that inspired Remnants. My artist's statement follows this story.

An artist friend had found this hummingbird and gave it to me. . . I saved it in the box for quite some time, not really knowing what to do with it. This was in 2000. Apparently it died with its feet grasping the branch, so it swung back and forth when the branch was

◀
Bug.

◀
Inspired by the movie *Independence Day*, I scanned my own alien using the broken end of a pelican femur.

▲

The Dead Tree

held upright. Over the next two years I began accumulating more dead stuff. The butterfly wings, the grasshopper skin, the dragonfly, the leaf membranes, and that weird looking thing on the left. I found myself being oddly drawn to dead and decaying objects. After awhile I became inspired to shoot a still-life of this collection. A bit of hot glue on the hummingbird's feet so it stayed upright, and for attaching the wings, and I was ready to shoot. This image was made on 4X5 color transparency film and lit with electronic flash.

My inspiration for making beautiful images from dead things began as self-therapy for dealing with a chronic health issue. Sometimes when artists experience pain, loss or suffering, they use that emotional experience as the root for creating a body of work. My time came at the age of 15, and again at the age of 26. I was experiencing pain and numbness in my right arm and shoulder. I underwent spinal cord surgery both times in my neck. To make a long story short, the surgeries were successful but the anger at my affliction almost consumed me. After many years I was able to redirect this anger into artistic expresssion. Look deep enough and most artists have these back stories. Back stories are helpful in explaining what drives their work. Examine your reactions to your life and see what creative ideas develop. However, you may not like what you find. To take oneself down to those layers of the soul, holding the keys to explaining current behaviors is a daunting task and leads to other places you may not care or dare to know and understand. I want to understand. I know it can be painful. I do it because it cleanses me in a way nothing else can. It is my therapy and I embrace it.

Because of this health issue it became important to me to possess my medical history, including the various film records. Eventually I began scanning these film records to see what type of imagery could be made from them. My sister-in-law, a veterinarian, also sent me hundreds of old x-rays of dogs, cats, turtles, chickens and eagles. Some of these were scanned. The series, called *Bone Daddy* which developed out of these scans, is perhaps a subject for another time. Examples are on the DVD. *Remnants* is the offspring of *Bone Daddy* and it lives on!

My artist's statement can be seen in the box on the next page.

Whew. Now you know *why* I do this particular art form. The balance of this chapter will be about the how.

When I show people the work and explain the process to them, they look confused as they digest the information. Some still don't get it when I tell them that it's all done using a desktop scanner. "Oh, you mean you make a photo, print it, and then scan the print?" It has

been amusing, to say the least, and gratifying that I can create this level of interest in the process.

When I teach Photoshop, object scanning is one of the required assignments. Students embrace this assignment and its creative process and thank me for opening up their eyes to new possibilities. Hey, that's what a teacher is supposed to do.

The example I've chosen for this writing is one that was produced at the request of my wife and son. Apparently they were out in the yard and came across this praying mantis skin and couldn't wait to present me with this new piece of dead.

I wish to take a short excursion into one of the many stories I've accumulated during my career. Since I've been working on Remnants, it seems my friends can't wait to give me dead things. Imagine my curiosity being piqued when I open my front door and there is a shoebox with the word "Stern" scrawled across the top.

Imagine further: When I open said box, I find a lizard, a frog, a bird (or bird parts in a baggy), and more. I love my friends; they are participating in the artist's process.

The subject of this chapter is the scan of an exoskeleton of a praying mantis. Look at those textures. I like the cropped version better; the whole bug is too obvious, not abstract enough.

This screen-grab shows an attempt at combining a few leaves with the mantis skin. After some thoughtful consideration, I decided to go with the skin on a plain background. Ya gotta try it all, just to see how it hits you. The creative process does not waste time. Even when an idea is rejected, valuable information has been gained about personal preferences and vision.

MY ARTIST'S STATEMENT: *REMNANTS*

A small part or portion that remains after the main part no longer exists.

Discards. Trash. Icky Stuff. Yuck! Just get rid of it. But I'm drawn to the textures, shapes, and intrinsic design qualities of these decaying organic and inorganic materials.

By photographing this subject matter through a macro lens I'm able to see objects differently than before.

Remnants began as an exploration of macro photography of small pieces of natural detritus. Although I had taken many closeup photos of plants and animals with film, I wanted to see these objects at 2000% without using traditional photographic methods. *Remnants* references the works of Irving Penn during the 1970s and Karl Blossfeld during the 1930s.

Scanners are a special class of imaging device, but how best to use one? In the mid–1990s, I began studying how to convert my photography skills from analog to digital. During this time, I began to understand that the quality of a digital image is predicated on how the numerical sequencing in a file is initially generated and saved. The numbers define resolution, bit-depth, print size, tonal levels, and color appearance.

I was beginning to appreciate the differences between how an analog camera and a lens see an object, and how a computer—through a scanner—sees that same object, to make an image. All digital devices have limitations. The trick is to understand those limitations and learn how to work with them to maximize results.

In 2002, I began producing a series of images that were founded on the idea of using a desktop scanner to create macro photographs without benefit of the traditional setup—that is, a macro lens, a camera body, film, and special lighting equipment.

I wanted to prove to myself that by understanding the advantages and disadvantages of digital imaging with my scanner, I could produce images on par with the analog method I was used to. Although a scanner produces images with extraordinary quality, there are some limitations. Depth of field, selective focus, camera angle, focal length, and perspective are either limited or nonexistent when using a scanner. Therefore, placement on the scanning bed and angle to the light source are extremely important when working with this method. I do, however, have unprecedented control over brightness values, color, contrast, and output size.

I'm pleased with the results because what I'm seeing in my head and what I'm able to print onto paper match up quite well. The visual solutions I pre-visualize (there's that word again) drives the technical decisions I make. I'm thinking about the texture of the object and the texture of the paper on which the object will be printed. I'm thinking about the object's color and how well I'll be able to translate that onto the printed page. I wish to make interesting and beautiful images that are colorful and rich in textures. I like to view these images frequently and always see something new that I didn't see before. ■

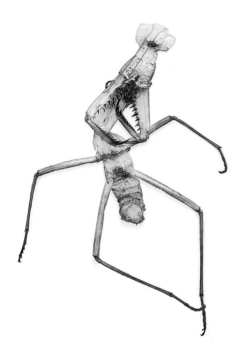

Screen grab of mantis skin with leaves.

This is the original scan

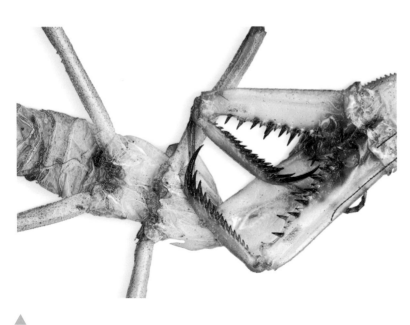

Cropped version of mantis.

Before I make the final scan, I set these parameters: 48 bits per channel, 600 ppi, enlarge between 250% and 2000%. Even though your scanner's dialogue box may indicate dots per inch (DPI), under the resolution setting, understand scanners work only in pixels per inch (PPI). This can be confusing, but PPI refers to file resolution and DPI refers to inkjet printer resolution.

I also sharpen at this point. Sharpening is an adjustment to the luminosity and chrominance numbers which boosts contrast. We are setting these numbers into our files from the beginning, in high-bit depth. It does not harm the file. My first rule in scanning is to produce great RGB numbers for Photoshop to crunch. A healthy file equals a healthy print. Just sharpen, baby. The first rule in administering first aid is "Do no harm." The first rule in pixel-based imaging is "Do no harm." Hello! We are doing no harm because we're sharpening

during the genesis of file formation. Scanning maps analog (continuous-tone) information into discreet pixel values. A side effect of this process is an overall reduction in contrast from what the original scene or object contained. This is inherent in all forms of digital capture. The color isn't as rich, either. What do we do? We boost the contrast and color saturation by sharpening during capture, similar to what happens when a JPEG file is created inside a digital camera. The big difference here is the quality. Scanning creates a superb and extremely flexible file in terms of editing. I've found the preview window to be accurate for judging the effects of sharpening. And guess what? I do one additional step that helps make this sharpening step a no-brainer: scan at the absolute limits of the scanner's abilities.

I access the histogram section of the scanner interface and pull out the histogram sliders beyond the values set by the pre-scan. In the example below, I pulled them out to 0 and 255. This is OK, but a bit of overkill. The leaf example that follows was done with much less movement. Be sure though to set the output sliders at 0 and 255. Make sure the gamma (midpoint) is set to 1.00, and make sure the Curves tone curve is set to a straight line, just like the Curves dialog box inside Photoshop.

This is my recipe, and it ensures that the data comprising the actual scanned image resides within a huge ball of data that I'm then able to edit (safely) until the cows come home, are milked, and put away. At this high bit depth I have a file containing over 65,000 editable levels of tonal information and over one billion theoretical color choices. This method generates spectacular results.

Why, it's almost like you've created a RAW file without using a camera. Reread the differences and similarities between a scanner and

The Epson v750PRO scan settings referred to in the text.

a digital camera as discussed in my artist's statement.

Another advantage of creating a data file this large is being able to crop later in the editing and creative workflow stages. I hide my crops instead of deleting in case I want or need to recall the information later. Remain flexible and your creativity will soar.

I'll walk through the things I concentrated on while working on this Remnant.

Layer Masks

Masks aren't just for Halloween. They are without a doubt an integral part of any critical Photoshop work. You need to master working with **Brushes**, **Calculations**, **Filters**, **Color Range**, adjustment layers, and **Channels** to maximize efficiencies when generating masks and minimize the time spent working with them.

Adjustment Layers

Placing an adjustment layer (hue and satura-tion, for instance) above the background and forcing the values to change dramatically makes the image look lousy to us, but appeal-ing to the **Color Range** command. This com-mand, found under the **Select** menu, works by identifying color differences in a file. It stands to reason that if you force colors to over-sat-urate, then the process of making a selection based on these extreme value changes is one way to begin building a mask.

This technique works great, but not all the time. It takes practice to become familiar with its idiosyncrasies. However, once you've generated a selection outline, throw away the adjustment layer; it's done its job. Even when this technique of using an adjustment layer does a good job, the selection edges will usually require localized brush work.

Hey, if it was easy, we'd all be doing it exqui-sitely. It takes a lot of handwork to finesse a mask. You may as well get used to it. Quality dictates that we strive for perfection when masking.

If the above technique doesn't work (and it may not), then try using the **Calculations** command to generate a mask based on the blending of the luminosity levels of the chan-nels. This command was designed specifically to help generate masks. With **Calculations**, you can blend the value of a single channel with itself or another channel. You can also add the effects of **Blending Modes**. This is a tricky tool that takes practice to understand

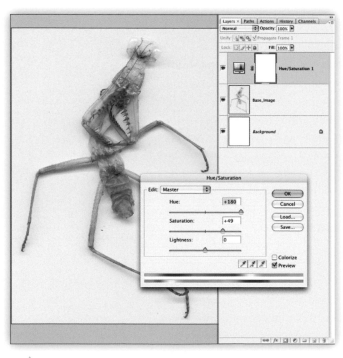

This is the Hue/Saturation (H/S) tweak used to force the values.

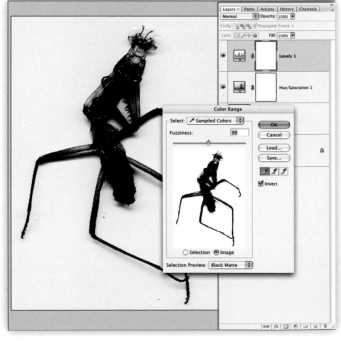

This is the Color Range generated selection outline based on the H/S set-tings on the left. I added a Levels Adjustment Layer to increase my odds.

and master. It can be used to make black-and-white conversions, too, but I use it mostly for generating an alpha channel, which constitutes the beginning of my masking process.

As I mentioned previously, one can use the **Calculations** command to make powerful black-and-white images. As long you appreciate experimentation and have patience, have at it. It's fun.

The technique of making black and white images using **Calculations** is pretty cool, but not as cool as getting the mask right.

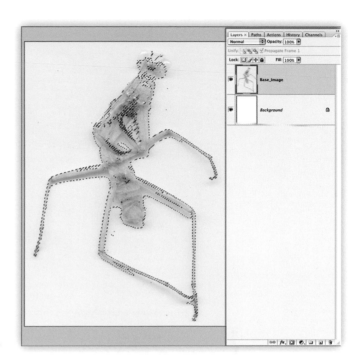

▶

This is the selection outline generated by Calculations, which is the basis for my mask.

▲

This is the Calculations dialog box.

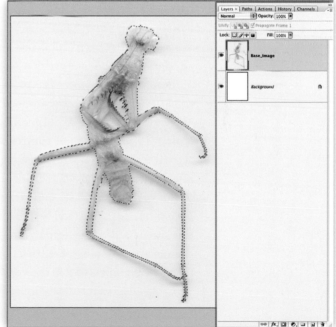

▲

After five minutes of adding and subtracting to the selection using the **Lasso Tool**, this is what I have after using Calculations and a bit of localized handwork.

▲

Masking is incredibly tedious. This particular mask took almost twelve hours to complete to my satisfaction. Must say, though, that I didn't mind—I "missed" my wife's liver-and-tongue dinner. Gotta love Photoshop!

The screen-grabs above depict two stages of painting in the edges of this mask. With a selection active, go into **Quick Mask** mode. With a hard-edged brush, add to the red by painting with black, and subtract by painting with white. In my workflow, I paint with a hard brush and then blur the entire mask after the painting has been completed. This way, all edges carry the same weight. A global blur at the end of the masking process ensures a consistent edge all the way around the object. This is important in making good images. It is always easier (and more controllable and accurate) to soften a hard-edged mask than to harden a soft-edged mask using **Levels** or **Curves**. When the selection edges have been properly placed (and before converting this saved hard-edge selection into an alpha channel for softening), I sometimes convert it into a vector and save it in the **Paths Palette**. This step ensures that I have a clean copy of the selection while adding a negligible amount to file size. Given that some Remnants are several gigabytes when opened, and several hundred megabytes when stored on the drive, every bit of file management is important.

Edges will look fuzzy at this degree of enlargement (300%), but no worries—a print will never print larger than 100% of its actual pixel dimensions.

In my workflow I use 100% hardness brushes for painting masks. I frequently zoom into 300%, and sometimes into a higher percentage, when painting/editing these edges.

Finishing Up

Once the image is properly masked and otherwise fleshed out, the finish work begins. Read the "Color Theory & Color Correction" tutorial on the DVD, which is my take on why we color correct images and how to set the endpoints for output. The tutorial may require a few viewings to be fully comprehended, but the method described, once mastered, takes only seconds to apply. This is not a new technique, but it is presented in a different way. My workflow demands that digital images being printed to any output

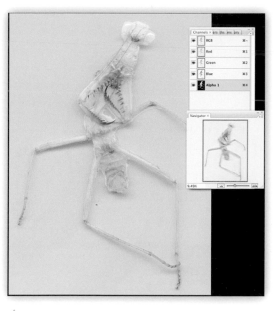

▲
This mask is just about finished.

device has to be adjusted to fit the parameters (limitations) of said output device. This tutorial may help you the way it helps me. Good luck with it and let me know if you need clarification.

The ability of inkjet printers to reproduce shadow detail with contrast and saturation is compromised because paper absorbs ink. This phenomenon is referred to as dot gain. Dot gain causes loss of detail and, to some extent, desaturation. Highlights are about how little ink is put onto paper and how little ink is absorbed into the paper. Setting numerical stops at each end of the brightness range of a file (highlights and shadows) is a procedure distilled down to several simplified steps that are adjustable and accurate. Alternatively, paper and printer profiling devices produce data files (.icc files) that describe the dot gain characteristics of a particular paper-and-ink combination.

For Remnants, I decided that a print format would be established to ensure the work had a unifying look no matter the content. I decided upon a paper size = 13 x 19 inches and an image

size = 11 x 15 inches. If the object is on a white background, it is framed by a thin black keyline. When the object is against black, no keyline is needed. Either way, the image dimensions are identical.

With the advent of CS2, smart objects have become an invaluable alternative to resizing pixel dimensions within a given file. This nondestructive way to up-and-down sample images has simplified the workflow by allowing multiple size changes depending on my mood. And believe me, I'm moody.

Finally, there are times when I just can't resist the temptation to add a bit more to the image. This is accomplished by duplicating the layer and blurring it about 25 pixels. The layer's **Blend Mode** is then changed to **Overlay** or **Softlight**. The opacity is lowered for the final patina.

We're talking degrees of subtlety here, not wholesale changes to the intent, content, or meaning of the image. It's enhancement, not celebrity plastic surgery. Look how rich the image now looks below on the right. The colors are richer and the highlights glow.

▶ Once the image is finalized, I drag and drop it into this template file and "save as …"

▲ I converted this Remnant into a smart object because it needed a severe crop and resize to maximize its visual impact. The mask attached to the smart object allows me to scale at will while ensuring that the black keyline prints.

▲ The claw of a sparrow. Looks like an underwater creature to me.

▶ Robins Nest. Notice how the eggs are resting at the top instead of the bottom of the nest.

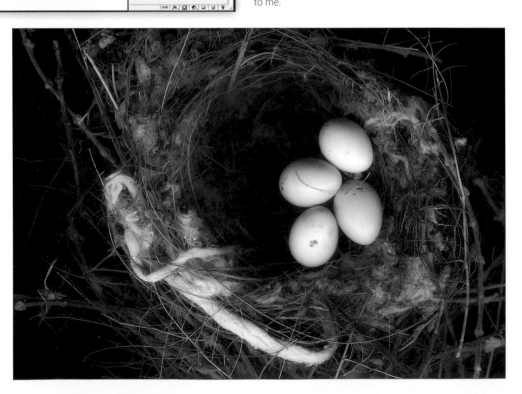

Dust Bunny

Fish Feathers

▲ Dried Leaf

▲ Dead Lizard (Thanks, Dad).

◀ Two Leaves

Jaw

Rabbit Racer

Micro fine cleaning cloth, two camelhair brushes, anti-static brush, and an anti-static cloth.

Tools of the Trade

The following is a discussion about some of the tools I use, the setup in my office, and some of the scanner settings I have found conducive to my work.

Keeping the glass clean and minimizing static electricity buildup are important steps in minimizing Photoshop cleanup time later.

Scanner Setup

Most Remnants are scanned with the lid open. The Plexiglas sheet is supported by four machine screws. I raise and lower the sheet to just above the object being scanned. This is accomplished by turning the nuts on all four screws. The screws are marked at one-quarter-inch increments.

When a white background is needed, a light is placed above the sheet of Plexiglas. The intensity is managed by inserting higher- or

▲
Crushed Leaf.

▶
Squished Bee

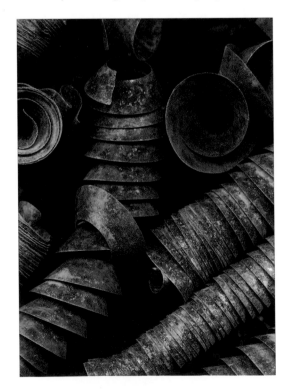

▶
Shavings

lower-wattage bulbs. Colored gels can be placed on the Plexiglas for other types of effects. If a black background is required, the Plexiglas is raised a bit and a piece of black paper is laid on top. In these examples, three-inch screws are being used. If the Plexiglass needs to be even higher, I place small pads of post-it notes underneath each screw. A simple, practical solution—and economical.

There are times when crumpled black foil is used to achieve a black background. In the example to the left, the crumpled-foil look supported the industrial nature of this piece. I used a **Curves Adjustment Layer** to open up the darkest shadows enough for detail to print.

For the image upper right, I put a leaf on the bed and shut the lid, which gave me the desired result. The closed lid gave me a perfectly clean, white background.

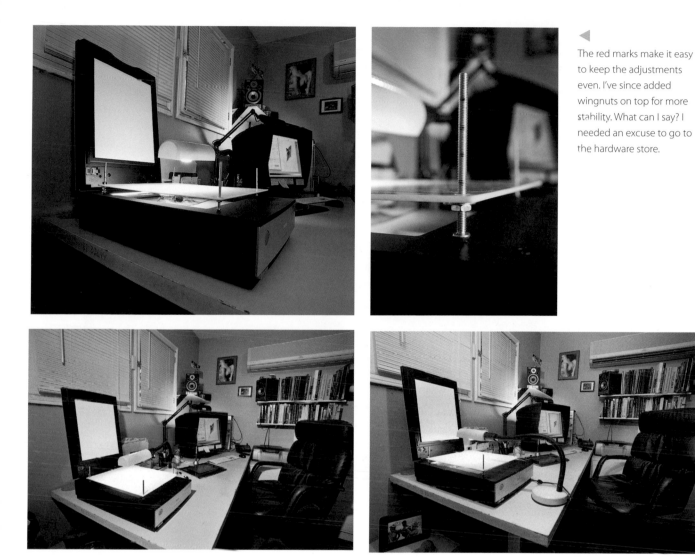

◄

The red marks make it easy to keep the adjustments even. I've since added wingnuts on top for more stability. What can I say? I needed an excuse to go to the hardware store.

▲

With this setup, moving the light to the front is easy to accomplish.

▲

I work in a small, clean, and efficient space. The monitor is a CRT bought in 2001. It is calibrated religiously every two weeks, right before client work, and before working with any file containing skin tones. It truly is a WYSIWYG workflow.

Can you imagine doing this still-life the traditional way? How would you begin? How would you break the leaf into pieces? How would you support the broken pieces to get those wonderful shadows?

Small, dried objects work great with a closed lid. Wonderful things can happen.

Squishy, liquid-filled things like bugs do not work great with a closed lid. How do I know this? Of course I tried it. Disgusting what comes out of a bee; it ain't honey. And I can do without the cleanup afterward, thank you very much. I now have knowledge of what does and doesn't work with a closed lid. But don't take my word for it—squish your own. Try vegetables or other non-bug subject matter. As for me, I'm done squishing bees, spiders, ants, and other little critters. Just to let you know, they were all dead before they got to me. I didn't lay a hand on 'em. Honest.

▶

I like Epson scanners be-
cause the interface is easy
to use and understand.

EPSON Scan

EPSON Scan

Mode:
Professional Mode

Settings
Name: Current Setting
Save Delete

Original
Document Type: Reflective
Document Source: Document Table
Auto Exposure Type: Photo

Destination
▶ Image Type: 48-bit Color
Resolution: 600 dpi
Document Size:
W 3.75 H 6.52 in.
▼ Target Size: Original
W 9.38 H 16.29 in.
Scale: 250 %
Trimming:
⚬ Off ⦿ On

Adjustments
Reset
▼ ☑ Unsharp Mask
Level: High
▶ ☐ Descreening

Preview Scan
☐ Thumbnail

Help Configuration... Close

This screen-grab indicates the usual set-
ting used to scan a Remnant, or for almost
anything else for that matter. I use 48-bit color
at 600 PPI for my resolution. I know it says
dpi, but we are working with square pixels at
this stage of the file's genesis and not round
dots. Why do manufacturers use the incorrect
term DPI and not the correct term PPI? I really
don't know, but it is confusing. Why do I use
600 and not 1200? Or 9600? First, I don't scan
beyond the physical limitations of the scanner,
ever. Interpolated resolution is software-
driven, a sales gimmick and is of no real help
unless you're in marketing. Will somebody

please get these marketing guys out of here?
The reason I use 600 ppi is this: Years ago I
called Epson customer service with an issue I
was having with one of their professional scan-
ners and wasn't getting the answer I needed.
As I became more frustrated with the lack of
progress in resolving the issue, surprisingly
the rep sent me to someone in engineering.
The person I spoke with told me Epson scan-
ners (at that time), were optimized to work at
600 ppi. I've been using 600 ppi ever since. To
this day I get terrific results.

Do you recall what I said about sharpening
earlier in this chapter? Well, this is where I per-
form my sharpening routine. I recommend not
avoiding this step. A high-resolution, high-bit
file contains over sixty-five thousand discrete
tonal levels and over one billion theoretical
colors. If you decide to change the values later,
print quality will not be compromised due to
the high level of information built into the file.

Next is the scaling adjustment. This will
range from 250% to 2000%. Everything
depends on the subject and whether I think
I may want (or need) to crop the image later.
With high-bit, high-resolution files, cropping
will not result in poor-quality prints. I'd rather
have more info and not less for this reason. I
also prefer to scan only once. Objects can dry
out or are so delicate they become damaged
during the initial scan, losing that special qual-
ity. Enlarging while scanning is how I increase
the level of detail.

The **Histogram Adjustment** at right shows
what adjustments were needed to make a pure
white background for masking purposes. These
settings are for generating a mask for later
use; they are not the settings used to scan the
object for detail and color information. Please
understand this distinction.

This makes the Photoshop portion easier
to accomplish because the **Quick-Selection**

The pure white background made via the scanner controls.

Compare the shadow in the scanner preview above to the finished shadow below. It's the little things that make me happy.

Tool can be employed to grab the white for removal via a **Layer Mask**. The next screen-grab of the leaf shows how it will look when the **Histogram Adjustment** sliders are pulled outside the range of the settings used to get the white background above. This is how I want the leaf to look in print, but with a white background. Both files are used in Photoshop to get the white background of the former with the darker, moodier tones of the latter.

As mentioned earlier regarding the scan of the praying mantis skin, it is crucial to pull the highlight and shadow sliders outside the range that the scanner sets during the preview process. The automatic settings are frequently pulled in from the highlight and shadow ends of the tonal scale (0–255). I pull them out manually, which results in a dull and darker image. This is a good thing. Why? 16-bit, 600 ppi enlarged files—that's why. Once inside Photoshop, editing, toning, and color

enhancements can be done without damaging the file. Think of it this way: a huge ball of data has been generated within which resides in the file. There is a tremendous amount of extra information which makes it very easy to shift this image into virtually any color or tonal quality I desire. Knowledge is power, the power to make beautiful art with minimal compromise.

Shavings, Trains, Dads, and Sons

Experience leads to knowledge. Knowledge leads to understanding. Understanding leads to growth. Growth leads to better work. Better work leads to satisfaction. Satisfaction leads to a better life. I am on this path. Life will try to knock me off, and will sometimes succeed, but I know where I'm headed and I can get back on track.

At the age of four, my son was enamored with trains. On Sundays we would go to the local commuter train stop to watch freight trains running at twilight. As we walked the tracks one Sunday and waited for the next train, I spotted metal shavings all over the ground near the rails. These shavings came from the holes bored into the rails. I knew immediately I had a Remnant.

The problem was, my pants pockets were small and full of keys, cash, clippers, and more. "Nat, come here, son, Daddy needs you!" I must have seemed a bit crazy stuffing his little pants pockets with metal shavings. At this point in his life, with both parents being artists, he was getting used to these episodes of inspiration. Plus he knew there was ice cream in his future after a trip to the trains.

After we had ice cream, we went home. I relieved my son of his cargo, he went to play with his trains, and I carefully placed the shavings into a baggie.

At my studio, the shavings were placed on the scanner bed. For hard objects, I place a 3 mm-thick clear sheet of pristine acetate to protect the glass from scratching. Black foil was a staple in my expendable-supplies cabinet and proved to be the perfect choice for the background. I cropped the image prior to scanning

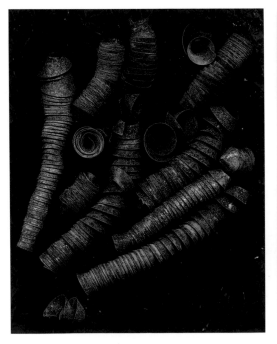

Origiinal scan.

Image Size dialog box. 600 ppi and 48-bit depth.

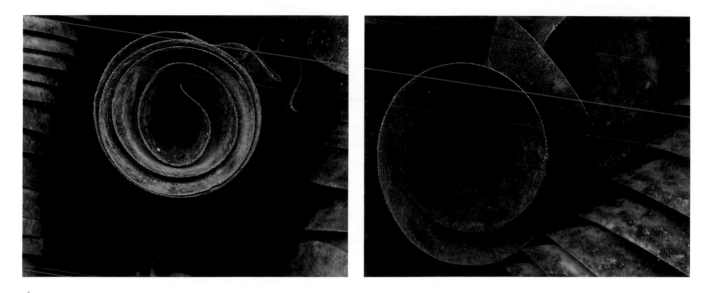

Above are two crops I was considering at one point.

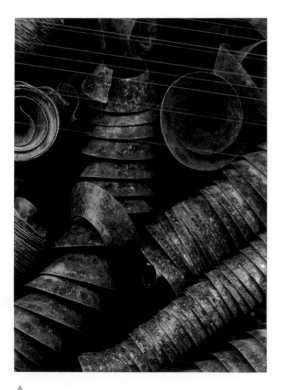

This is one of the most beautiful pieces in the series. At 13x19 inches, it is awesome.

because it made a better image. I also cropped because it is difficult to compose upside down and backwards, sort of like a view camera but without the bellows. When scanning multiple components, the luxury of moving an individual piece just so and immediately seeing the result is missing. I have to put them down in what seems like a good composition and preview. I'll futz with the composition for a bit; sometimes I nail it and sometimes it's cropped after the fact. As long as I get the intended results, I'm good..

After scanning, but before printing, I use Photoshop's image size dialog box to reset the resolution to my preferred 360 ppi. I do this with the "Resample Image" box unchecked (which doesn't add or subtract information, it merely redistributes it along the raster grid). This results in a document size of over 18x14 inches, larger than the format I established. I mentioned earlier that I cropped this image to better fit my vision. After cropping the file, I up-sampled to the preferred print size using Genuine Fractals. So even with my protocol in place, I still had to upsample. Oh well, the best laid plans ...

Final Thoughts

Over the years friends have left little gifts for me on my doorstep. The family cat has also left offerings on the doorstep (although they were usually not dead yet). I am no longer surprised when I see a box with my last name on it on the front stoop. Lizards, crabs, bones of all kinds, leaves, and frogs have been gifted to me by friends. I am officially saying thank you for all the dead stuff left on my doorstep, and keep those Remnants a-comin'.

Sometimes I'll be having drinks with friends and someone will say, "Hey Stern, I've been saving a bug for you for awhile, I gotta get it to you; it's freaking out the wife." Or worse, they'll pull it out of their pocket and give it to me on the spot. Ugh! Students have also brought things to me. My dad was fond of Remnants and often saved stuff for me. Because he lived in Palm Desert, CA, the objects he saved were well preserved from the dry heat. He passed away in late 2006. I miss him a lot. I know what you're thinking, and no, I didn't try to scan him.

Although...

Fern.

Rose Petals.

Film is Dead

CHAPTER 4
Great Product Photography

I have photographed thousands of products and objects during my career and I have a few things I would like to share with you now. Great product photography is always in demand. Unfortunately, these days it seems as if "good enough" product photography is the norm. And Norm is the guy I buy computer supplies from. His wife just had their second baby. He'll be buying lots of baby products. He'll be looking at product photos. Hope they're good enough. See how it all works? When you can, however, pay with cash. Cash helps control the buildup of debt (which can be like stepping in quicksand when you're self-employed), and you can negotiate substantial discounts when paying for products or services with cash. I've been doing it for years; it is powerful, real, and I highly recommend getting in the habit. I use plastic, but only when I have the money already in place to pay the bill when it comes in. This takes discipline but it is worth the effort, and is emotionally and mentally freeing.

During my halcyon days, it was not uncommon for one of my 80 clients at The Walt Disney Company to call and ask, "What are you doing now?" I would reply, "Working for you, of course." Life was good working for the Mouse. Paid for the house, cars, vacations, and investments. I delivered gold-plated work and never felt guilty about what I charged. We love the Mouse at our house.

The products I photographed for Disney were dolls, puppets, statues, stuffed animals, and other licensed products from their films and television shows. Two major reasons for my success in photographing these types of products were my passion and my ability to capture just the right point of view. I also had a knack for adding that little something extra to finish off an image. Often it was nothing more than the cast shadow from a cardboard cutout suggesting a window frame, palm tree, human form, and such. Cast shadows from off-stage cutouts produced amazing and saleable results. The effect was enhanced by adding a colored gel. A businessperson looks for ways to increase the quality of their products and services. They strive also to find ways to increase profitability. For me, off-stage cardboard cutouts served both these objectives well. The photographs were better, clients were satisfied, and my profit margin increased.

How did I succeed so many times? Well, you've come to the right place my friend, 'cause I'm gonna tell ya'. As part of the discussion, I will revisit several seminal moments that shaped my professional outlook. This outlook has guided me in the myriad and difficult decisions confronting me daily as a self-employed professional artist.

The Beginning of My Journey

In October 1979, I opened my first studio in Hollywood soon after graduating from Art Center College of Design. It was on Hollywood Boulevard on the second floor above the Woolworth's store. I partnered with a fellow student, which, in retrospect, was a huge mistake. I truly misjudged his character. Although I came out of this mistake a better person and artist, it was a painful and humiliating experience.

We used my family connections to help build out the interior and to purchase furniture and fixtures. When it was finished we had a nice studio that was efficient to work in and a fun place to hang out. Within a few months my studio partner began attacking my confidence. He began by asking out loud whether my parents made the right choice in sending me to Art Center. This was quickly followed by questioning me about my abilities as a photographer. I had never experienced anything like this. He went so far as to interrupt a portrait session to offer an unsolicited opinion that I wasn't doing my client justice. As a creative person back then, I needed validation for my thinking, my work, and myself. As I was launching my business career I needed it in big batches. I now began to question my abilities as this friend and studio partner successfully undermined me. After several months of this abuse I was so upset that it took all I had just to get out of bed. I'll spare you the sordid details but it was time to act.

Trying to protect myself I confronted him in front of some the other tenants and the landlords. This was a tactical mistake. I was not discreet. Much later I realized he had always abused me when we were alone. That was my undoing, acting out in front of witnesses. I was asked to leave by the landlords, who were smitten by him. I was humilated and embarrased to have lost my way and my standing with the others in the building

I set up studio number two in Burbank with a friend (and mentor) who had a place. He worked a few weekends here and there so essentially I was alone, and it was a good fit. And Burbank is a great place to work if you're self-employed. My former landlords called to inform me they were glad I left. This hurt my soul because I didn't think I was a bad person. I always try to do the right thing. It bugged me but there was nothing to do but move forward and continue to build my business. About a year or so later my former landlords call, along with a few of the tenants. The phone call was apologetic in tone. They had experienced the same behavior from my former studio partner and had forced him to leave. They asked my forgiveness and invited me back to take over the balance of the lease. The high I experienced for being validated taught me a valuable life lesson that I want to share with you.

I chose not to return without a moment's hesitation. They were mistaken in their assessment of my character. At that moment I knew my career would work, and that I was a good person. Now they knew it, too. I was right on in my assessment of my view of the world, my character, and my thinking. Validation! Finally! Up to then, I really hadn't had any validation I could hang my hat on. I was confused by the way things had played out in my Hollywood studio. This experience taught me a lot in the way I thought, the way I saw the world, and the way I interacted with people. I knew in my heart I had acted responsibly.

The point of this is: listen to your inner voice. If you have true self-love, it will not

harm you. It will not mislead you. It will be your guide and best friend. I learned this from that fateful phone call. It has carried me through dark times and, believe me, all creative people experience dark times. Some more than others, of course. The dark tunnel that experience forced me through eventually brought life-long light to my life view and made me a stronger person. I should really thank him some day. Not!

It wasn't all bad experiences during my time in that Hollywood studio. I decided that having a major Hollywood entertainment company as a client would be very cool. I purchased a copy of *Photographer's Market* and generated a list of potential clients. I set up interviews to show my portfolio. Although I did a lot of interviewing, I didn't have a lot of luck early on, but after I moved to Burbank I managed to secure enough photography work from ad agencies and small companies to help support my young family.

Working for the Mouse

My relationship with The Walt Disney Company (as it was called then) began by telephoning various buyers within the company. This selling technique is called "smile-and-dial". After almost two years of this selling technique however, no matter whom I called, the result was the same, no photography assignments. I met with and talked to people at the studio. I left behind promo pieces. They were polite, but for the most part indicated "thanks but no thanks". They had their photographers and they were happy with them. Then during one interview, an art director from their fledgling home video division threw me a bone. He ordered a 4x5 color transparency product shot

(for a newspaper ad) of a black plastic VHS cassette box. He ordered it on a Friday afternoon, wanted it by ten the following Monday morning. I decided then and there it was going to be the very best photograph of a black plastic box there ever was. My thinking during the first ten years of my career was that creativity came from perfect technical execution of the photographic aspects.

I sanded down the rough edges of the plastic box, I used my 4 x 5 view camera to ensure perfect vertical and horizontal lines, and lit it so the three viewable planes of the box had differing amounts of light to provide both shape and depth against the clean white background. I knew I had to make this box sing. It had to be better than they were expecting. This was my shot and I wasn't going to waste it. I sweated over this assignment all weekend and shot a lot of Polaroids. This wasn't just a job. It wasn't just a cheap black plastic box. It was my passion. It was my dream. It had to be excellent.

My attitude was inspired by the career of Victor Keppler, a photographer whose heyday was the 1950s. He had a situation early in his career where an advertising agency gave him an assignment to photograph canned spinach. This was in the day when canned vegetables were a relatively new thing—awful tasting and ugly to look at. He had to shoot this ad in black and white, no less. He was determined to make it the very best shot of canned spinach there ever was. He succeeded and enjoyed a long career as a commercial photographer. His story taught me an important lesson, one that I am now handing off to you. I am so very grateful my parents bought me Victor's book. I still have it and frequently reflect on its lessons. Thank you, Mom and Dad. You did a very good thing for me. A life-long lesson.

It's a little before ten on Monday morning and I walk into the art director's office. He took my 4 x 5 chromes, tosses them on a light table, glances, and begins to turn away as if to say, "Nice try kid". Suddenly he does a double-take and is now admiring how well rendered the box is. He was impressed and I was in! So began my career with the mouse.

I lucked out again during this time because my new studio partner was my first and most important mentor. He taught me how to be self-employed, and provided valuable lessons, incredible friendship, and support. Quite the opposite from my first studio experience. Things were going great until he moved out to pursue other goals and I hurt my back. After a brief hospital stay, I spent six months of recovery time at home. I used my savings to keep the doors open but couldn't get any traction when I was back on my feet again. During this time I met the owner of Photographic Illustration Company (PIC) at a Chamber of Commerce breakfast. He offered me the opportunity to work for him as his director of photography. I took the job.

The very best thing about working for PIC was being given the opportunity to build up a small account. The account was The Walt Disney Company. Since I already had a relationship with them, the road to building up the account was well-marked. I was paid a salary, given an expense account, and earned commissions on all sales over a predetermined amount. It was a great ride. I was part of a team of PIC employees who helped build the account into one of the top two for PIC. We accomplished this in three and a half years. We were good and had a lot of fun doing business with them. I also learned how to provide top customer service. I left after four years because the owner reneged on his promise to sell the

company to the buyers I had lined up, my second neck surgery, and a divorce. In spite of all that I learned so much during that time about people, business, and negoiating with clients and vendors.

I made my first foray into teaching at this point. I walked away from the business I had built up for PIC. Left behind a career and all those profitable Disney contacts. My fledgling teaching career was going great until I was involved in a car accident. Fortunately, I wasn't hurt too badly, just my head hitting the roof. But it did make me cross-eyed. Great. A cross-eyed photographer. I had no choice now but to get into special visual effects. OK by me. It was time to get another studio.

During this first stint as a teacher, I was also getting calls from many of my Disney contacts who weren't happy with the drop-off in customer service since I left. I was amazed PIC didn't jump all over them after I left. Keeping the Disney business at PIC was like shooting fish in a barrel. Why they let this slip away was a mystery to me. Disney people would call me and I would refer them back to PIC. After several of these calls I spoke with the upper management at PIC and said the next time anyone from Disney calls I was going to accept their business. The question was, how to set up a new studio. Remember, I was divorced, I didn't have a lot of resources, I had a three year-old daughter visiting frequently, and I was living in an apartment.

Being somewhat nervous about getting another studio and the financial commitment it required, I decided to hire a photography studio on a per-job basis to shoot jobs. I would act as the account executive, salesman, and producer of the shoots. This worked for about six months until the three photographers who shared the studio began to nickel and

dime me to the point where the stress became more than the fun and profit of working with them. Mind you, I was bringing them work. They didn't have to lift a finger to bring in the business. I paid them deposits. I paid what I owed them on a timely basis. As I see it, they choked off a mutually beneficial and profitable relationship. I had to move on and, again, set up a real studio for myself. As per my usual, I took away another terrific lesson from this experience: have multiple income streams when you work for yourself. One of the photographers I worked with also made furniture. He did this because the photo business has its ups and downs and he wanted to ensure sufficient income to live the lifestyle he wanted. Great lesson. Again. Within a year, I began to develop multiple income streams from shooting, licensing, teaching, and investing. Life was good.

I leased a two-bedroom apartment in Toluca Lake and used the living room as my studio. I must thank my oldest brother for his advice and guidance, as it was he who said I shouldn't look at the expense and commitment of a two-bedroom apartment as scary but rather use it as motivation to become successful. Bingo! That really hit home. One of those aha! moments. After moving in, I made one phone call to a contact at Disney and said I was back in my own place. She was excited to hear this news, as she had just gotten out of a meeting and wanted to see me about a project as soon as possible. I met with her, did the project, and made everyone happy. Business was great, but I quickly outgrew the living room, as the projects from Disney were becoming plentiful and huge. That aha! moment turned into many ka-ching! moments. I didn't look back for a decade.

My next stop was a co-op studio in North Hollywood. I also picked up another teaching gig, this time at my alma mater Art Center College of Design. The co-op ended after a year and a half, because the building's lease expired and the video producer who ran the place decided to move out of town to pursue other interests. I've had an interesting journey. And I learned another great lesson from this experience, how to run a co-op. I applied this knowledge when setting up and running my own co-operative studio from 1990 through 2006. I landed at my last studio in Burbank, the co-op where I stayed put for 16 years. You can see what it looked like by viewing the Santa Girl movies on the DVD.

The Theory Behind What I Do

It seems the business model for the entertainment industry is "I need it yesterday!" For years I specialized in last-minute, no-notice, rush work. Lucrative, but it really messed with my social life. I cancelled many dinners and delayed a few vacations to take care of my business. Once, while on vacation in Hawaii, I called my studio everyday to oversee a few Disney jobs farmed out to one of the members of my co-op

The first step after the arrival of products for a shoot is spending time closely looking over the products: looking down, looking up, looking left, looking right, head on, three-quarters left, three-quarters right, profile, from eye level, and from the back. Each view provided information about how the product was designed and what its best look was. I can't emphasize this part enough. Get to know your client's product line. These particular toy products had specific expressions or poses that were indicative of

their individual personalities, and were often based on television or movie characters. My job was to photograph them in a way that enhanced this design aspect. This was part of the fun. I got to art-direct and shoot. In fact, I often had a third job, too: that of a product prep person. The product usually arrived in boxes, wrapped in plastic, or in packaging. Someone had to get the stuff out and ready for the close-ups. I billed clients for my creative photography, art direction, and product prep. If I was responsible for three jobs, I felt it was proper to be paid for three jobs. When a client objected, I suggested they send over an art director and prep person to work with me. When they didn't have those people on staff to send, I explained to them that all products had to be prepped and a design (art direction) is needed so I knew how to shoot their product in the best way possible. I bill for these additional services. That explanation seemed to do the trick.

If the client could not accommodate my request to send over the products, I would go out and pick them up. If I got stuck for an idea, I would go to a toy store to check out how the products were displayed, or view segments on TV, or perhaps a CD or video clip. My job was to be prepared. I never failed a client-driven assignment.

Baby Kong

This baby gorilla is swinging on a pole. Notice the turn of its right ankle, the tilt of its head, and the open palm of the right hand. All these attributes were deliberately created to make this toy look like a young, swinging primate with young, human, childlike characteristics. What follows are some of the mechanical,

technical, and stylistic aspects of the photograph.

For a long time (in the pre-digital era), I used a Cambo Master PC view camera for product work. Kodak EPP 4x5 color transparency film was my preferred stock. Using a 210mm lens (my preferred focal length and workhorse lens) and four lights was usually all it took for a simple yet powerful product shot. These product shots went for about six hundred bucks apiece and took several hours for setup, shooting, and film processing.

The background light creates separation between the product and the background. The light behind the product (camera left) was pointed at the gorilla's right backside. This edge lighting creates the highlights along the right side, the top of the head, and the top of the pole. Three specular (direct) lights and one diffused light were used in this setup. The main (diffused) light was positioned about 45 degrees from the lens position and up high to push the cast shadows at a downward angle. The last light was positioned camera-right and creates the long highlight along the pole. I work with many lights to form pools of light that mix together to form the connection between product and viewer. Notice also that the pole and the background are the same color. The chosen color is slightly lighter than the color of the gorilla. This created the softness that was essential to the overall tone of a portrait photograph of a baby gorilla. Portrait? Of a product? Absolutely. I look at this type of product as personality-driven and action-oriented product portraits. It worked for me, and my clients were always happy.

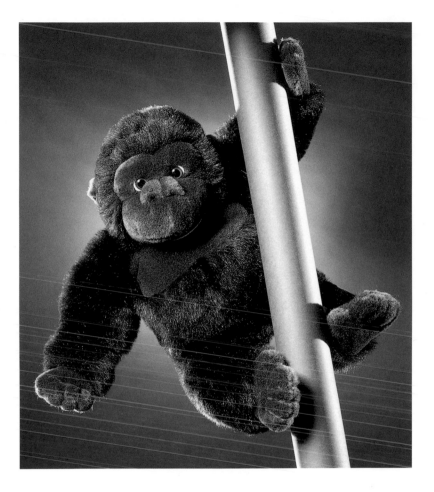

▶

Basic four-light set-up for Baby Kong.

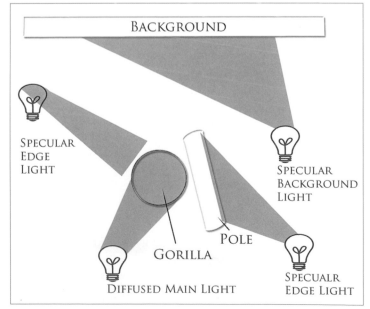

▶

Approximately 100 puppet portraits like this were shot for the catalog.

Sid and Marty Krofft Auction Catalog

In 1997 I was commissioned to art-direct and photograph *the* auction catalog for Sid and Marty Krofft Pictures, Inc. During the initial meeting with the auction house representative, Marty, his lawyer, and one other unidentified person (after all, it *is* Hollywood), the rep told me to just throw the stuff on a gray floor and shoot the photos. No big deal. What? You've got to be kidding. I was surprised at his callous approach. These auctioneers were used to selling off aerospace parts, not objects from the entertainment industry. I didn't know how they got connected to this project, but they weren't getting me to shoot this historic stuff like nuts, bolts, and metal sheeting. In their view, if people wanted it and saw it, they would buy it. I assertively informed them that if we didn't make the catalog a must-have collector's item there was no reason to have me involved. This was a dicey move on my part—I ran the risk of losing the client, but I took the chance because I was not going to produce anything less for for Sid and Marty, two of my childhood heroes. Fortunately, Marty agreed with my position and I ended up art-directing and shooting the catalog my way. After the auction sales were tallied, Marty told me half-jokingly that the catalog was the only thing that made money. He was glad he listened but wished it hadn't cost so much to photograph. This was in 1998 and my creative fee was twenty-five-thousand dollars. I mention this to give you an idea of what commercial projects should cost. I've been to too many informational programs sponsored by photography organizations where the participants talk about how they made a particular photo but not what they charged. Withholding fee information from a group specifically there to talk about the business always bugged me so I'm doing my part and telling you what I charged. I licensed unrestricted reproduction rights, kept the copyright, and got back the original film. I am proud of this accomplishment.

The puppets I photographed had definite personalities. And posing was going to be the key to each and every photograph. Notice the poses of the puppets on the facing page. Notice the shape of the background light, the color of the light, and the stage-like quality of the light hitting the puppets. All of these considerations made a successful catalog that sold out and made a week of principal photography worth the sweat, tired feet, and aching backs.

The spread of the background light was altered by raising or lowering the background seamless paper. This changed the shape of the curve and, by definition, changed the shape of whatever illumination fell upon it. A medium gray value seamless was chosen so that whatever gel I put over the background light(s) changed the background to that color. How did I pick the dozens of colors that worked so well with so many differently colored subjects? That was the easy part. I scrutinized each puppet's color scheme. The gel chosen was either a complementary color or a matching color. If I wanted to make the background darker, I added a neutral-density gel to the lamphead (to darken), or, if it needed to be brighter, I increased the power going to the lamphead. This meant when planning the lighting scheme I had to ensure that extra power was available from the power pack to send to the lamphead if need be. Planning the lighting scheme and lamphead power ratios beforehand paid off deep into the shoot when we were all getting tired and a bit daft from the long hours. Both of my assistants were aware of my lighting plan and it was easy for them to execute and control. Paramount lighting (light placed near

▲

Notice the position of the background lights (inside the red circle) above the seamless background. The second light was added to extend the edges of the lighted background area and for more control over how well the edges were defined.

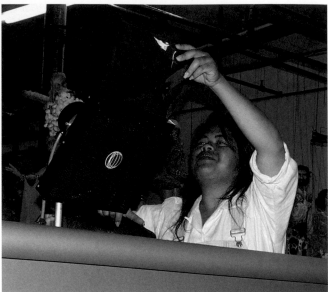

▲

Cindy, one of my assistants for this shoot, inserts a blue gel for the next puppet portrait.

▶

At the end of each day's shooting, equipment was covered with plastic to keep out dirt and dust. Remember, I have to fix whatever breaks, so I take care of my stuff. Plus I don't want any of my gear to fail on the job.

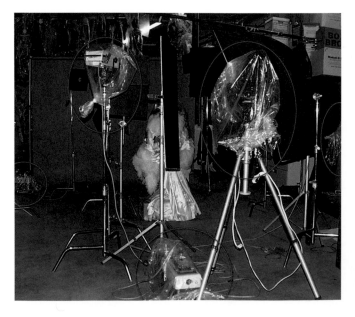

An important aspect of working in-studio is making sure none of the lights strike the front of lens. One of the biggest technical mistakes made in studio work—a mistake that causes re-shoots—is lens flare. In this photo, you can see the three lens (flare) shields surrounding my camera. They are outlined in red. On my black grip belt is a telescoping rod with a mirror on one end. From behind the camera, I position the mirror so I can see the front of my lens to determine the exact placement of the shields and to reposition them if they get bumped. The telescoping mirror can be purchased at auto supply stores nationwide. Operators are standing by. Order now. Supplies unlimited.

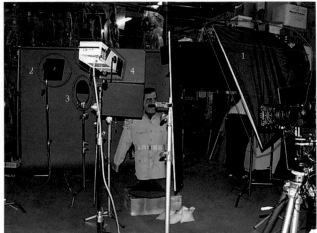

In this photo, I have identified the main portrait light set for a classic loop lighting pattern, with the light placed about 20 degrees off the optical (lens) axis. This is the softbox camera-right (1). The rim light is far left (2). There is a grid spot on the lamphead to restrict the light to just the head and shoulders (3). And the 1/2 scrim in front of this light adds one more level of light intensity control. It is placed to lower the light intensity falling on the shoulders. This was necessary due to the difference in reflectance of the lighter colored jacket vs. the darker colored hair. The 1/2 scrim evened out this difference. Knowledge is power. And makes for building a better photograph. The rectangular light is a focusing spot and was used on all of these life-size puppets. It was positioned to light up just the eyes and the bridge of the nose (4). Worked great and added just the right amount of that special something I bring to my work.

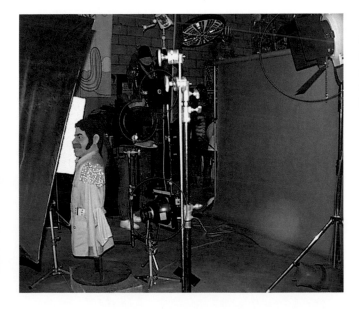

Another view. The large light, upper right, is my other focusing spotlight. It drew the edge along the left side of the puppets. The smaller light to the left made one edge and this made a larger edge. All in all a nice balance. I work with studio flash units for jobs like this. Hot lights take more energy, create heat, and require higher ISOs if a lot of depth of field is needed.

the optical axis (lens), high above the camera) was a good choice for the puppets. The color of the light was neutral. I used a Mamiya RZ 6x7 camera and exposed about 130 rolls of film and about 200 Polaroids. Digital capture was available in 1998 but film-based commercial photography was more economical at that point and it's results more predictable. Not for long though.

Listen and Learn

An important aspect of client relations is developing the ability to know when to listen and when to talk. When you work for yourself, talking (always selling yourself) is a necessary component. You end up tooting your own horn a lot. You have no choice unless you have a person whose job it is to sell for you. Listening is the flip side of talking and must be given its due. Learn to do it for the sake of your career.

I was on location photographing selected props and puppets from an animated film of a popular children's story for an auction catalogue. I was working on a shot when two of my clients who were present began a semi-private conversation. I was not involved in their chat, but I listened very carefully nonetheless. My mind began checking off ideas as I realized what the gist of the conversation was. They were discussing their options for the back cover. The hard part was listening before speaking up. Getting the facts first made the sales part easy. Way easy. Easy to hit the important points that drove their conversation. This was an opportunity for me to expand the shoot, be creative, and make some extra dough. First, though, I had to get into sales mode.

I have a videotape of *The Music Man* queued to the spot leading up to the "Ya Got Trouble" musical number. Before I would leave my office to make a sales call, I would play that song-and-dance number to marvel at how Professor Hill got the townspeople nodding in agreement about the perceived trouble and how he got them fired up to take action. I used this approach and positive energy to get myself in sales mode, and then off I would go to make my sales call. It was effective for me but it's not for everybody. This conversation was happening right now and I had to switch into sales mode from creative photographer mode. I was able to do this effectively thanks to Professor Harold Hill.

Talking up ideas to my clients is the easy part. I'm very comfortable with this aspect of the business. Can't wait to speak up and offer my creative solutions. It is, however, a calculated approach. It's my business to know my client's sensitivities: I know when to speak, know when to listen, know when to take notes, and know when to change course. Great for navigating these tricky waters. I knew these clients, I'd been working with them for years. So after politely getting involved in their conversation, I offered my idea of a still-life of the puppets as a back-cover bleed. They thought it was a great idea. After that days' shooting wrapped, I went back to my studio and began designing the photograph and budgeting its production costs and licensing fees. When you're on a roll, you don't hesitate, you grab the business when it's in front of you, especially when it's an opportunity created through your own efforts. Research is important to any creative process; I watched the movie to understand the characters, the sets, the color palette, the light quality, and the dialog. Research eased the design part and it made it extremely easy to talk up my idea based on their needs because I knew the material and what mattered to them. They gave the go ahead. Now for the tricky part.

We had to negotiate my proposed budget. Notice how I said *we*? I view client relationships as a series of connected events in which we work together toward a common goal. I offer them something they need (talent) and they offer me something I want (work). Clients, of course, are compelled to get the most out of their vendors for the least amount of money. My job as a vendor is to get the most money out of them for the work being commissioned. Business for the self-employed is a linked chain of transactions. I'm a vendor to my clients and a client to my vendors. I'm in the middle. I negotiate with my clients for the highest fees and I negotiate with my vendors for the lowest costs. I attempt to make money on both ends of a transaction. Profit is what business demands. I'm not self-employed to break even. No job is too small and no profit is too large. Quality and service are paramount. I made my proposal, we discussed it, and after sharpening our pencils on a couple of sticking points, they approved the additional expense. I truly feel honored and lucky to get to do what I'm passionate about and good at. A gift, really. One to be cherished.

Cloudy Skies

This discussion will breakdown how I produced the cloud/fog effect using my preferred analog method back in the day and how I produce it today using Photoshop. I have experimented with several Photoshop methods for creating cloud/fog effects and the one discussed here is the easiest for me to control. I spent three days setting up and shooting this image and it took my clients one day to sign off on it. It is incredibly gratifying when good clients buy into your vision and appreciate what you do for them.

I want to discuss how the fog effect above was made. This shoot was done in the pre-digital era. In the good old days, photographers were trained to do as many effects as possible while film was in-camera and being exposed.

The bottom of the image. I used my fog machine to make the cloud effect. Looks more like the peach is having a smoke.

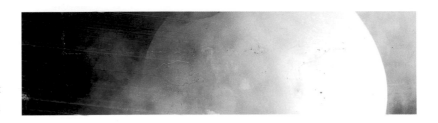

Second attempt at using the fog machine. Where's the fire?

As you can see by the Polaroid print at the top, not enough of the peach is being enveloped by fog. Plus you can see one of the sandbags used to stabilize the set. A portion of the movie takes place while the peach is flying over water. So a cloud or fog effect became the obvious choice to complete this story of this

The analog version of the cloud/fog effect. In case you were wondering, that's a giant peach.

image. But how could I create this effect? Look at the Polaroid again and you'll notice smoke in front of the peach. This was created with a fog machine. Great tool, but not the right tool for this particular task. I needed something more sophisticated. Just to make sure, I shot it again with the fog machine. Even worse.

The final result was accomplished by placing a piece of framed glass in front of the camera's lens. In the latter part of this chapter, in a discussion about how I shot a ceramic skull with blue lightning effects, one of the production photos shows this glass-in-a-frame tool made specifically for laying in effects using analog methods. Check it out.

First I taped a bit of diffusion material shaped like a cloud formation to the glass. This was placed in front of the lens. White card stock,

cut loosely in the same shape, was positioned about two feet in front of the peach. It was about a foot in front of the lens. The distance and height were critical because the card had to be positioned far enough away from the lens to be lit but close enough to remain out of critical focus, even at the shooting aperture of f/32. The card had approximately three stops more light on it than the key light illuminating the puppets. It was necessary to light the card with this much intensity to compensate for the light energy absorption by the diffusion material on the glass. This kept the card at a brightness value appropriate for fog and for reproduction on the printing press. I designed this effect so

▼

Here, the positioning is
not quite correct.

▼

Correct position but not enough contrast.

▼

The five minute digital cloud/fog effect.

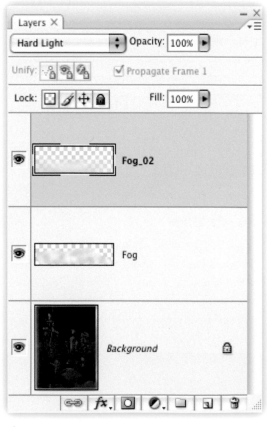

▲

The Blend Modes for Fog_02 is set to Hard Light @ 100% and Fog is set to Pin Light @ 90%. The Background has been deliberately obscured for legal reasons.

it would appear in print as something slightly darker than paper white.

Today this effect could easily be put into the shot during postproduction. For comparison I did just that on one of the Polaroids. To create a digital fog formation, I made a selection with the **Lasso Tool** first, in roughly the same shape as the clouds from the original. I went into **Quick Mask** mode and blurred the edge of this selection ten pixels. **Command + J** put this selection onto its own layer. **Shift + Command + Delete** filled the selection with the background color, which was white. The **Blend Mode** was set to pin light and the layer opacity was adjusted to 90%. This layer was then duplicated and the **Blend Mode** set to hard light. A **Hue-and-Saturation Adjustment** layer (named Color_Clouds) was grouped to Clouds_02. The Colorize box was checked and the color was warmed up. The Smudge Tool was used to rework the top edges of the clouds, and the Burn Tool was used to add subtle toning to specific areas to give depth. A nice effect as well. I actually like it better than the original. Took five minutes. Repeat after me: "Photoshop is great."

Final Thought

Remember when I stated earlier in this section that this was an opportunity for me to "expand the shoot, be creative, and make some extra dough"? Notice how the mention of money was last on this list? Being creative and getting to do what I am good at and love is what it's all about for me, and is incredibly satisfying. I learned early on that the money will flow if the passion and integrity are present first. This was my business model for capturing long-term dollars and success. Think about it and see how you can make this work for you.

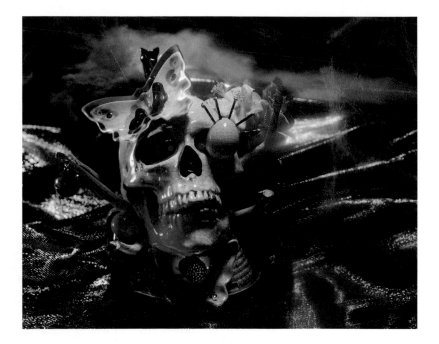

A Dark and Stormy Night

The idea for this photograph was inspired by what is arguably one of the worst opening sentences ever written: "It was a dark and stormy night."

My wife made this piece of art for a benefit auction. Before it left our house I was inspired to photograph it for posterity. A portrait, if you will. (I had a big hole in my schedule too, so why not fill it with a portfolio assignment?) The ingredients for this shot were: the skull, a highly reflective multicolored material made out of metallic threads, and nylon webbing used for making spider web effects. Commercial photographers, by definition, are pack rats and collectors. I am always on the look-out for stuff to buy for possible use in a photograph. The best time to stock up on Halloween stuff is right after October 31. The nylon webbing really makes this shot for me because it played a dual role as lightning and fog. The metallic material came from my cloth inventory. Every so often I visit fabric stores to see what they

▲

Old roll-paper cores from a photo lab were used as part of the foundation for a rolling landscape. I have always been a huge supporter of recycling and have used these roll-paper cores for years.

Client: SELF	Job #	Processing/Remarks (+/-/NOR/Snip)	Polaroids:
Description:	Date: 3/4/9.5	1 SET PROC N	Size/Type/Exposure/Filter(s)
SPECIAL EFFECTS IMAGE of SKULL SCULPTURE		1 SET PROC +1/3	8 TYPE PROCOLOR 100
		1 SET PROC +1/2	FILTERS on LITES only
		1 SET PROC	
		ALL FILM EXPOSED AT meter (N)	

Lighting Set-Up: (Include watt seconds, grid spots, diffusers and gels per head) Film: Size/Type/Exposure/Filter(s)

400 WS C-GRID WHITE/MAIN
C-GRID ORANGE 800 WS
C-GRID BLUE 2000 WS
210mm lens
MIRROR
S
T-LITE MAIN 400 WS
WEB
C-GRID BLUE 800 WS

4X5 ROP II EPP
EFFECTS AT 4 POPS F 32
MAIN 4 POPS F 45
EYES BURNED in 1 CYCLE F 22-

Multiple Exposure Yes ☑ No ☐

SEE NOTES FOR EXPOSURE SEQUENCE

Studio: 818-563-1942 Office: 818-848-4481 • 1915 West Oak Street • Burbank, CA 91506

have. I buy what appeals to me and what I think can be incorporated successfully into a photograph. Sometimes the fabric itself inspires a photograph. You just never know.

This shot had a lot of neat technical tricks, some of which I will relate here. Again, it was in the film days, so my techniques were designed to happen at the moment of exposure or during portions of a multiple exposure, which was the case here.

I have a lighting paradigms notebook and put in it documents like the one at left. It is from the skull shoot. These lighting paradigms list the client name, date of shoot, job number, film stock, Polaroid count, exposure protocol, processing preferences, and a lighting diagram; on the back was taped a final Polaroid and a test sheet of processed film. This reference book makes it easy to re-create a lighting scheme or visual effect.

One of my studio mates made this frame-and-yoke assembly specifically for special effects. This one was a foot square. We also had one three times this size. Spraying the glass with water and hairspray, wiping grease on it, taping gels and other materials to it—it was easy to render interesting images.

Shooting a colored light through this cookie created a dappled light pattern on the landscape.

This is the rear rail of my 4x5 view camera.. The tape marks identified how far to move the rear standard between exposures. The result was the ghosted outline around the butterfly wings on the skull near the cat. It's a Halloween-themed photograph and I wanted "spooky" effects.

The mirror reflected the hard fill light to only a portion of the skull front. The goal was to create uneven and multiple angle lighting directions to try and match the weird subject matter with weird light.

The production shot with the mirror shows some of the webbing stretched in front of the skull. This was lit by skimming a blue-gelled light across it. Several pieces of the webbing were placed behind the cat and along the top of the landscape. This became a rolling fog bank. The highly reflective and colorful nature of the material used for the ground created many lighting possibilities.

This image was created using multiple exposures. The lighting setup was designed to provide an aperture of f/22 but the lens was stopped down to f/32.

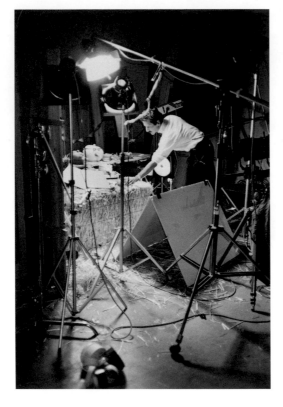

Here I am tinkering away at a Halloween-themed still life for a catalog client. Sometimes I became so trapped by the cables and stands I needed help extricating myself. I often wished for floating lights.

Normally this would lead to a one stop underexposure, but I compensated by popping the flash twice while the shutter was kept open in my blacked-out studio. Why make the exposure using this method? Well, the first pop of the flash gave the image its overall exposure value. Before I popped the flash units again, I racked the focus of the rear standard back to shift the focus point of the lens. This created the ghost-like outline around the skull. Take a look at the production photo and notice the tape marks on the rail. These marks enabled me to hit the same spot every time without having to refocus or guess. Predictability and control are intertwined goals. With this disciplined approach to creativity I am able to create all kinds of imagery that turn out technically efficient and professionally done.

Location Product Photography

I received a phone call from the VP of marketing for an international company specializing in products for broadcast television. She was looking for a Burbank-based commercial photographer to come to their facility in Burbank and shoot one of their very large and very expensive servers. She found three names in the yellow pages and I was the first one she called. I was glad—and surprised she let that slip out. This was critical information I wouldn't have given out so early in the initial conversation. Keeping your ears open and your mouth shut is a great skill to master. There will always be plenty of time to talk. Asking clients and potential clients questions and actually listening to their answers makes me a great conversationalist. They get to talk about their needs. And I listen. Intently. And I make notes. There was no way she was getting off the phone without offering this project to me. I went into Professor Hill mode ("Ya got Trouble!") and after she described her situation I told her I was the best possible choice for this project given my expertise with Photoshop and location lighting.

Bingo! She agreed. I developed a budget and sent it to her. The completed photo is at right. The before shot follows. The photo was successful. She and the product manager were very pleased. This photo session provided us the opportunity to get to know each other and was crucial in making our association smooth, fun, and profitable.

As successful as this first shot was, it was the project commissioned seven months later that is the subject of this section.

The image was originally planned to be the cover of a magazine that was doing a story on the company. I was given carte blanche to do whatever I wanted as long as it fit the format

of the cover and left plenty of room for the masthead and subtitles. The other requirement was that the photograph had to include four products that were very different in size and weight. Together. In an "artistic composition". Their words, not mine. No worries. All I had to do was come up with an idea and execute it creatively, make it technically perfect and

professional, and finish on time. The budget was just under six thousand. Needless to say, I was very excited about this job. This was going to be so much fun!

▼

The photograph below is what was delivered to my client. Below right is the product as it appeared prior to lighting and retouching.

The Big One

This was the most complex and complicated product shot I ever produced. And it was done on location even though it has a studio feel to it. The final image is below. It is beautiful to look at, it fulfilled my client's needs, and it was a challenge to shoot. The high-definition monitor in back is five feet across and the server on the right weighs 80 pounds. It appears to be setting on a piece of highly reflective glass but, in fact, isn't. But you knew that, right? Imagine how heavy and large a piece of glass would be required to be strong enough to support all of the products depicted. The cost would have been in the thousands, and it would have been very hard to bend. Since glass doesn't bend very well it required a mixture of shooting the individual products in the field and putting

▶

Harris Corporation.

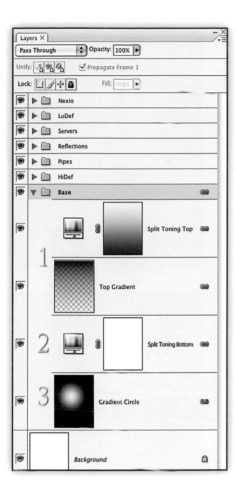

◀ 1

Look closely at the screen shot at left and notice how the *Split Toning Top* adjustment layer is clipped to the *Top Gradient* layer. This means that the effect of adjusting the color affects only the *Top Gradient* layer .

◀ ❷

A *Hue & Saturation* adjustment layer is set atop the *Gradient Circle* layer and renamed: Split Toning Bottom. **Blend Mode** is Normal. Opacity is 100%.

◀ ❸

The *Gradient Circle* layer. **Blend Mode** is Normal. The layer Opacity is 50%.

them together afterwards, including the creation of necessary shadows, highlights, reflections, and perspectives.

The reflection (which really sells the idea of glass) was created after I saw a reflection technique performed at a conference. I am constantly learning and mastering new techniques to make my workflow more efficient. Nothing new, here just reaffirming the benefits of being a life-long learner. The screen-grabs on the following pages show the Photoshop layers and their subsequent impact on the image.

The highlighted section is called Base and contains the four layers making up the

background of the image. The first one is simply a light gray layer with a **Radial Gradient** applied. I could have dodged out the lighter area with the **Dodge Tool**, painted it with white, or used the **Lighting-Effects Filter**. For my effects work, as long as I get there I'm happy. The criteria for getting there? Decide how easy it is to apply the effect and how easy it is to edit after the fact. The background effect was designed to allow split-toning. (The color and density of the top half of the background can be changed on the fly from the bottom half, simply. And at will.) This was done to fulfill the VP's request to vary the background color and

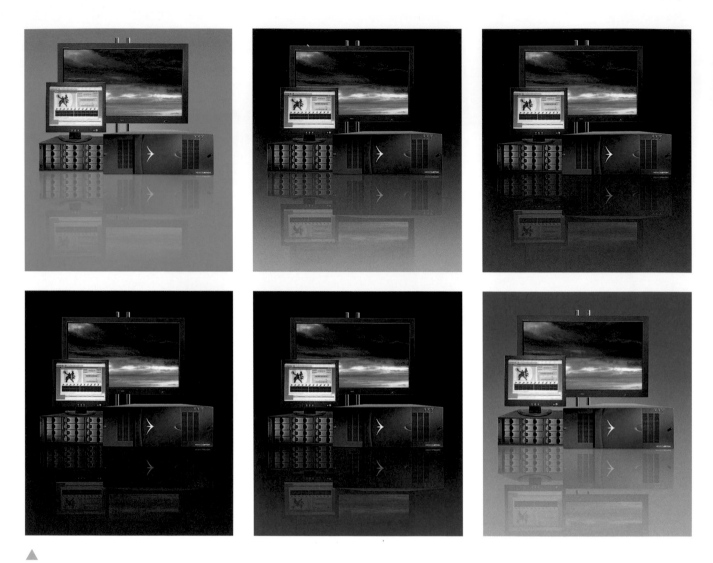

▲
Several examples of my split-toning on-the-fly adjustment effect.

brightness to see what she liked best. A huge part of my success in business is attributable to accommodating client requests as much as I possibly can.

In my film days I was able to create a split-toned background effect by taping two colored gels together and shooting light through it. To get this to work effectively, a neutral background had to be positioned at least five feet from the subject. The light with the gels had to be at least three feet from the background. When I wanted to change the color

combination, I had to prepare a different set of colored gels. Although it was relatively simple, it required a keen eye for color and lots of effort. Digital technology now makes this incredibly powerful technique incredibly simple. I encourage you to find your visual style and let it out.

My client was grateful and impressed when presented with the ability to change the background color and brightness value at her discretion. This is not a new technique, but it's one I've mastered. And the mastery

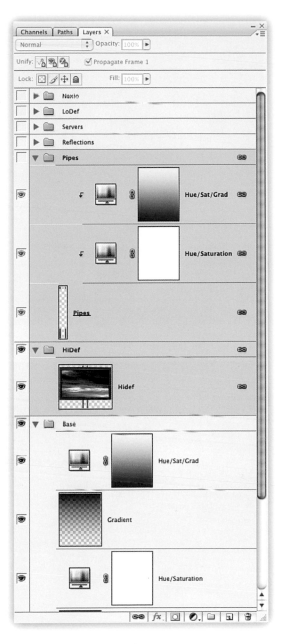

▲
The shiny metal is too shiny..

▲
The shiny metal is now the appropriate tonal value for the composite.

of these little things over time build on one another, which I can apply to projects as needed.

How This Was Done

The monitor was shot, the stand was retouched out, and the file was placed into the composition. An adjustment to the Pipes layer was necessary; they were too bright as photographed.

▶

Correct opacity for the "reflection".

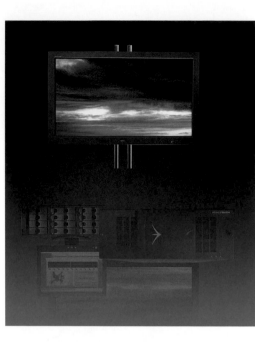

▶

Opacity of "reflection" at 100%.

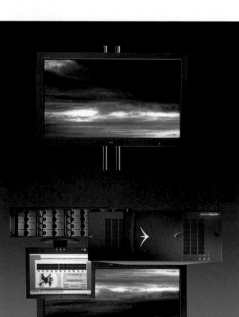

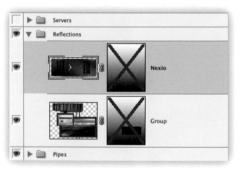

▲

The reflections were broken up into two parts for a more realistic effect.

I shift-clicked the masks to temporarily disable them before making this screen shot so you could see how this is simply a copy of the layers merged together, flipped 180 degrees, and finished off with two gradient masks and opacity adjustments to taste.

Very simple and very effective. Gives me a lot of control over the impact the reflections have on the image. Try that with film! The degree of control that digital imaging provides is a modern-day miracle.

Following is a breakdown of how the components making up this product shot composite were added and blended together. All components of this composite required a contact shadow when placed into the composition. I have turned off the visibility of the other parts of this **Layer Group** to make it easier to follow my discussion. In practice, the contact shadow is added last. After painting the contact shadow, I added a **Layer Mask** to control of the edges and density.

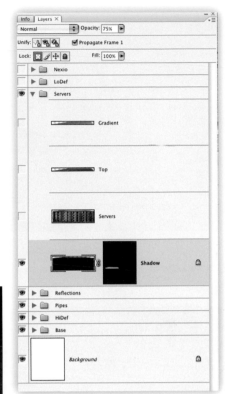

▼

The painted contact shadow.

▲

"Servers" added.

I added a new top because the shooting angle was off a touch.

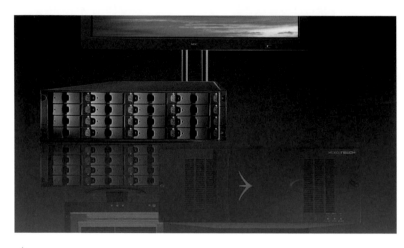

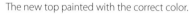

The new top painted with the correct color.

I made a new top to the server because the original shooting height was not ideal. Making a mistake when shooting digital does not necessarily mean a reshoot (like in the film days). It often means a trip to Photoshop. The difference between this *Gradient* layer and the *Top* layer is one of color. I had to colorize the *Gradient* layer with a warm hue so it matched the warm color of the image in the high-definition monitor. Had this been a live shot,

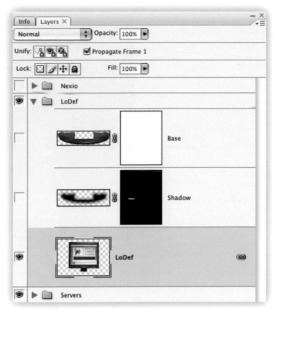

▲
The low-definition monitor is placed into the composition.

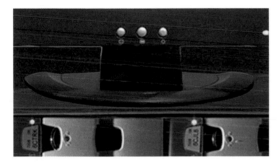

▲
The base is repositioned after having its perspective
tweaked a bit.

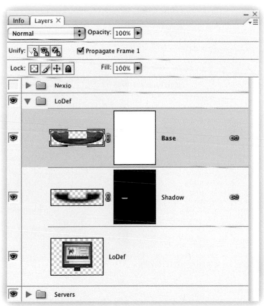

the warm color would have naturally fallen
onto the top of the server. I'm compelled to
notice these little things and make it happen
so the photo will appear realistic. I get paid for
thinking about little details.

After dropping in the low-definition
monitor, I dropped in the base separately and
painted in the requisite contact shadow.

Using Photoshop, I had to separate the base
from its top. This step was necessary because

I shot one of the components (again) at the
wrong height angle. I was confident I shot it
correctly but while assembling the composite
in postproduction, the issue of perspective
became evident.

No worries. With a bit of help from the
Transform Tool, the problem was solved.

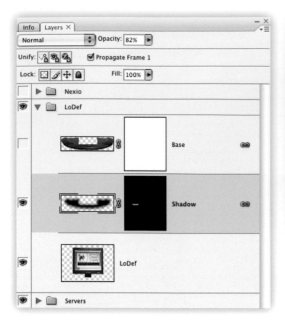

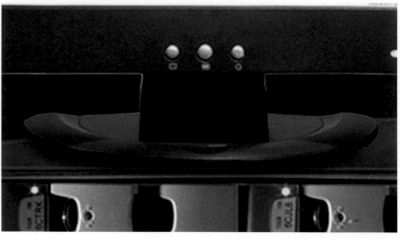

The base with its contact shadow in position

The Nexio set follows the protocol from the Servers group of layers. The contact shadow is painted in, and the Nexio is positioned.

The contact shadow for the Nexio. The opacity is set at 65% as are most of my contact shadows. Cast shadows are often in the 35-45% range.

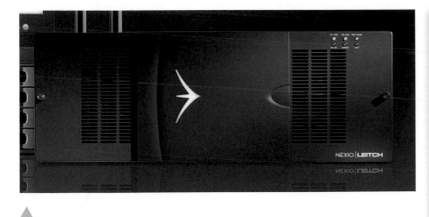

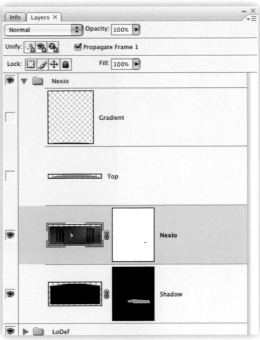

The Nexio with the *Top* layer turned off.

A new top was also added to the Nexio product for the same reasons stated earlier. I could have shot all the components at a variety of camera angles and heights and then picked the ones that matched. For me it was a question of shooting time allotted by the clients budget and knowing what I could do in post. The trade off was a no brainer. It takes less time to fabricate a new top in Photoshop than shooting a lot of extra frames and deciding which ones fit the best.

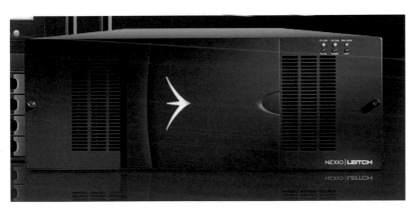

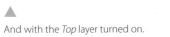

And with the *Top* layer turned on.

▶

The completed Nexio with a new top and properly colored with a gradient.

I know my stress level and choose a working protocol that maximizes my strengths and minimizes my weaknesses. By knowing my mind as well as I do, over time I increase the amount of successful and saleable images I produce. Know your mind when doing creative work and success will follow.

The completed image.

Reflecting

Additionally, I thought I'd walk through the process of creating the reflections and dealing with the special problems I faced in working this effect.

This grouping below was used as the basis for the reflection. The Nexio is on its own layer because its reflection is such that it does not look like a true reflection when merged with the other elements and pulled down together. The screen shot directly below the grouping illustrates what I'm referring to. Notice the alignment problem when all elements are moved together. The gap beneath the Server is distracting and had to be adjusted.

▲

The grouping I reflected upon.

▲

Elements in position but the gap is incorrect.

The Nexio layer group is duplicated and merged into a single layer named Nexio. Same for the rest of the layer groups in the stack—they are duplicated and merged into single layers. These new single layers are then merged into a new single layer, named Group, which is put into a new layer group named Reflections. I now have two new separate

layers: Nexio and Group. After repositioning the two layers correctly, each individual layer is ready to be transformed. I select Group. The transform-bounding box is present. The layer is flipped vertically and pulled straight down (to taste) while holding the Shift key to keep it aligned. When I am satisfied with the result I hit the OK button.

The Nexio layer with its transform bounding box and pull handles

The transform steps are repeated with the Nexio layer.

The layers are nudged into their respective positions. **Linear Gradient Masks** are applied to each layer. The Group Layer Mask has an additional solid black area added to block out completely the portion of the Group layer that is overlapping the Nexio layer as a result of using two separate layers to create a single reflection. Without this added solid black area, the reflections do not ring true. This is a classic example of one decision (making two separate layers) creating an issue (overlapping reflections) farther down the postproduction process that must be dealt with. Another example of a little detail having a huge impact on the believability factor.

With the **Linear Gradient Mask** and the solid filled black area matching the dimensions of the Nexio.

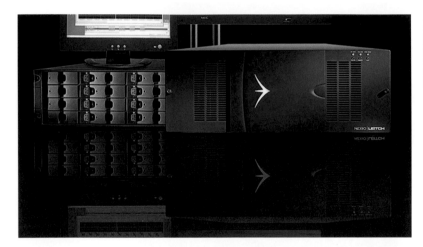

And without.

Look closely at the product shot on the bottom of page 126 and you'll see how the areas of overlap are confusing. Think about the relationship being presented here. If the server was really behind the Nexio in a live shot, the reflection would be behind as well, not in front. My background as a film photographer really comes in handy when producing photo-graphs like this. Possessing this knowledge will improve your images and income.

If I wanted to, I could have merged these two layers together after applying the effects of each **Layer Mask** separately. This would have given me one master layer with the effect permanently applied. I like keeping my options open so I chose to keep the layers separate.

▲
Here is the finished "reflection" in position at full (100%) **Opacity**.

▲
A **Linear Gradient Mask** was applied with an opacity adjustment. A reflection naturally fades as it travels away from the source. This is reflected here.

Gradient colorized and masked.

Summary

Product photography presents its own special challenges. I hope you've gained an appreciation for the theory behind what I do and for the importance of identifying the optimum point of view of a particular product and building a photograph around this decision. Focal length, light qualities, contrast ratios, color, depth of field, shutter speed, multiple exposure techniques, and postproduction all impact my decisions when constructing an image. These choices are made with the idea of supporting the intent of the designers and manufacturers of the product.

Simple photography is made visually appealing by making thoughtful choices and enhancements. I often select a neutral, seamless background and color it with gels placed in front of the light fixture. I create lighting setups producing drama, nuance, and movement in the photograph, which in turn creates an emotional response in the viewer. My light must not detract from the object but support it in all of its positive attributes (size, shape, color, texture, and form). Accentuate the positive attributes and downplay the less-photogenic by hiding these lesser qualities in the shadows or setting the composition in such a way that the camera sees only a specific angle. Shallow depth of field can work wonders in minimizing certain aspects of a product while bringing clarity to others.

Lighting is a two-step boogey. Illuminate the areas you wish to call attention to and shade areas you want to minimize. If one doesn't approach lighting this way, the photo can easily become over-lit and flat or under-lit and dark. If a photograph is lit with without keeping certain characteristics of the product in mind, you can end up with an image that is boring to look at (flat) or overly dramatic. Images that are dark and contrasty or with a lot of saturated color (or all three) will be difficult and expensive to reproduce on press, with less than optimim results. Lighting solutions that make a photograph self-conscious such that it becomes more about the lighting and less about the object or product are generally not going to work as well as a more mindful approach. A good photograph does not call attention to its process. A balanced photograph moves the viewer through the photograph and creates the intended emotion and response.

Providing clients with professional service means always making yourself available. You must give them what they want when they need it at a price you both can accept.

Well, I'm finished now. Time to hang up my shingle on the topic. Thank you for joining me on this journey. We all have a different journey to take. We must make our own path—even though we share similarities, we must also honor our differences. The point is not to be envious or jealous, but to embrace and celebrate each other. Very easy to say, but, believe me, I know how hard it is to do. But we must try. Trying and failing brings knowledge, quitting does not. Part of your job is to discover your path and to begin to explore it. My association with NAPP (National Association of Photoshop Professionals) has been an invaluable resource for me and others, worldwide. I recommend that you join professional organizations and take advantage of the educational opportunities they provide. I wish you the best of luck in your journey.

— *Michael*

▶ Parkins Furniture

▶ Pret-A-Poulet by
Margaret Adachi

◀

Maestro! (personal work)

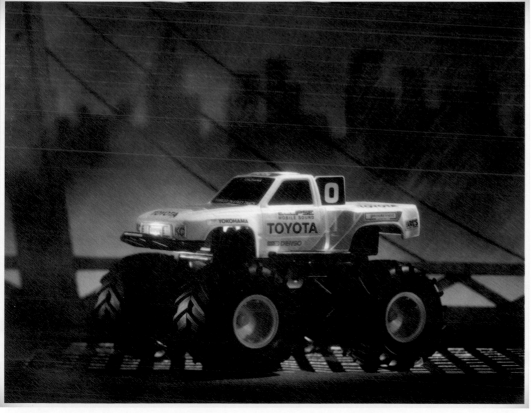

◀

Tamiya America Corporation

Index

I am a Creative—

I create images to communicate ideas in unique ways. I don't want what I do to just be good — I want it to be exceptional! Because I plan to make this my profession. I'm ready to do what it takes to get where I want to go. And I want a school where everyone feels that way. I want to be encouraged to dig deep into this thing I'm so passionate about and go for it with everything I've got. I want to learn alongside instructors who are professionals and students who think like professionals. That's why I belong at **Brooks Institute**. They've been getting the best out of creative perfectionists like me for over 62 years. At Brooks I don't just learn it...

I live it.

PROGRAMS
Bachelor of Fine Arts Degree in Film
Bachelor of Fine Arts Degree in Graphic Design
Bachelor of Fine Arts Degree in Professional Photography
Bachelor of Science Degree in Visual Journalism
Master of Fine Arts Degree in Photography

I LIVE IT.

We get you. Taking pictures is your passion. You plan to make it your life. Just like the photography students at Brooks Institute. They're at Brooks because we take photography seriously. So do they – their photographs show it. If you're looking for the real deal, you belong at Brooks Institute, too. Because here you don't just learn photography, **You Live It.**

PROGRAMS

Bachelor of Fine Arts Degree in Film
Bachelor of Fine Arts Degree in Graphic Design
Bachelor of Fine Arts Degree in Professional Photography
Bachelor of Science Degree in Visual Journalism
Master of Fine Arts Degree in Photography

Call for more information or apply online
1.888.304.3456 WWW.BROOKS.EDU
27 East Cota Street, Santa Barbara, CA 93101

Brooks Institute
PASSION. VISION. EXCELLENCE.

Photo Credits: 1. Hobson 2. Morrison 3. Quintenz 4. Manookin 5. Lesser

CEC2299423 06/09

If you like, keep up with me at any of the following links:

Website: CyberStern.com

Blog: digitalbeast.wordpress.com

Facebook: facebook.com/Cyberstern

Presentations: slideshare.net/Mr_Pixel